DIETS

DIETS

DIETS

DIETS

DIETS

DIETS
DON'T
WORK

DIETS

DIETS

DIETS

DIETS

DIETS

DIETS DON'T WORK™

by Dr. Bob Schwartz, Ph.D.

Breakthru Publishing
Houston, Texas

Diets Don't Work™

First Printing of First Edition: February 1982
First Printing of New, Revised Edition: February 1996
Second Printing of New, Revised Edition: July 1996

Copyright ©1996
by Robert M. Schwartz, Ph.D.

ISBN 0-942540-16-6

Library of Congress
Catalog Card No.: 96-83096

Published by
Breakthru Publishing
421 Emerson Street, Suite 1
Houston, TX 77006
Phone: (713) 522-7660

Printed in the United States of America

Acknowledgments

I wish to thank the following people for their direct and indirect support, and for all they contributed to me personally and professionally to make my vision and this book possible: Oprah Winfrey, Tom Leykis, Sally Jessy Raphael, Regis Philbin, Jenny Jones, Cherie Carter-Scott, Alan Dolit, Robert Adamich, Kate Solovieff Martin, Carol Costello, Leah – the love of my life, the *Diets Don't Work* Staff, the first 5,000 men and women who went through my **Diets Don't Work** Seminar Programs, and the 600,000 who read the first edition of *DIETS DON'T WORK* and used it to change their lives for the better. Thank you all.

Some of the names in this book have been changed, but the facts are accurate.

My special thanks to Jo Ann Gerhardt, Beth Ann Rea, and Jack Mayer for their help in editing this new, expanded and revised edition.

**Book and cover design and typesetting
by Jack Mayer Designs**

Warning

Use common sense. If you have a medical condition which prohibits you from eating certain foods, don't eat them. Foods that hurt you are called "Poison." If you want to be a *naturally thin* person, but you are limited in the foods you can eat, eat the best choices available to you.

Focus on what you can have, not what you can't have. If there are 10,000 foods available and you can't eat 1,000 of them, what should you do? Concentrate on the 1,000 you can't have or the 9,000 you can have?

Preface

In this book, Dr. Bob Schwartz takes you step by step through the discovery of how your weight really got there in the first place and how to take it off without effort or dieting. This breakthrough approach involves a transformation not only of your body, but of your entire attitude toward yourself and your life.

This book is intended to have you discover four things for yourself:

- The real reasons you have not lost weight and kept it off;
- A method that is working for literally hundreds of millions of people in the world that keeps them thin without dieting;
- A new relationship with yourself, a new self-image based on you also being a *naturally thin person*;
- How to end weight as a problem for everyone to whom weight is an issue *once and for all*.

Congratulations! By reading this book, you will soon discover that you have taken the first step toward living the rest of your life without weight being an issue in your life.

The Editors

Table of Contents

Part One

What You've Suspected About Dieting Is True!

Chapter

1

Diets Don't Work

Beware: Treacherous Waters

Picture yourself standing on the bank of a river filled with angry, hungry alligators. The water is churning and boiling over the banks. On the other side of the river is *Happyland,* where all the thin people live. A simple river crossing is all that separates you from your desired body weight..

There are exactly 200 people ahead of you. They all jump into the river and start swimming. Immediately, the alligators attack and the water churns even more violently. After several agonizing moments, the sole survivor of the feeding frenzy pulls herself up onto the other bank. She waves at you and calls across the river, "Hey, come on over. It's *great* over here!"

Your group of 200 is next. Would you go? Probably not. You might yell back, "I'm going to wait until Monday," or "I'll hold off until my next New Year's resolution."

Is it any wonder we approach weight-loss diets with something less than enthusiasm? You'd have to be crazy to jump into that water. But we do — over and over again.

A 99.5% Failure Rate

The prestigious *Washington Post* has reported that out of every 200 people who go on any diet, only ten lose all the weight they set out to lose. And, of those ten dieters, only *one* keeps it off for any reasonable length of time* — *a failure rate of 99.5%!*

*Special to the *Washington Post* by Arthur Frank.
Reprinted in *The Houston Chronicle,* December 8, 1980.

Over 26,000 popular diets have come and gone over the past seventy years and still only *one person out of every two-hundred* loses all their excess weight and keeps it off by dieting. *One* out of every *200*!

In studying that *one* successful dieter, I discovered that they did almost everything *compulsively*. They ate compulsively, brushed their teeth compulsively, and even cleaned their home compulsively. It was natural for them to *diet* compulsively. Compulsive people find dieting easy. If necessary, they'd eat plain no-fat yogurt and grapefruit every day until doomsday.

Never Trust A Weight-loss "Expert" Who Hasn't Been There

Between the ages of thirty and forty I personally lost over *2,000 pounds* from dieting — not all at once, of course, but on successive diets. For twenty years I owned a chain of health clubs across the United States. A large percentage of the people who came to my clubs wanted to lose weight, and at the time, the answer seemed simple — just exercise and stick to a diet plan and the pounds will roll off. *Right?*

Wrong.

After many frustrating years, I discovered something you've probably suspected all along — *diets don't work.*

Some people who went on diets lost weight, but few of them lost as much as they wanted to lose. Almost *all* of them gained it right back. For over twenty years we beat our heads against a brick wall. People who said they wanted to lose weight would come to the health club, and we would put them on a well-balanced weight-loss diet and exercise program. As soon as they went off the diet, the pounds would return — plus some.

If All Else Fails — Do It Yourself

I became so frustrated that I decided to test the diets myself, even though at the time I didn't need to lose weight. I wanted to *prove* to everyone that it couldn't possibly be as hard as they made it out to be. I went on the diet that was popular at the

time. My body soon ached as if telling me it didn't like what I was doing to it, but within a week I had lost *eleven* pounds.

After going off the diet, I gained back the weight I had lost. Soon I had a chance to try out the next few diets that came along. I had similar, though not so dramatic results. One day, I noticed that my pants felt tight. I'd been going on diets to prove something, to test them out. Now for the first time, I really *needed* to go on a diet.

As time went on, no matter what kind of diet I tried, the same pattern would emerge. I would follow the diet to the letter and lose anywhere from ten to forty pounds. When I would go off the diet, I would gain it *all* back again — *plus some*. I actually developed a weight problem by testing the weight-loss diets that everyone else was using to lose weight.

In the beginning losing and gaining weight wasn't a problem. The weight came back very slowly over a long period of time. When I gained too much back to be comfortable, I would find a new diet. With 26,000 diets floating around, finding a new one was easy.

The problem was that every time I lost weight, it took longer and *longer* to get the weight off. Every time I gained the weight back, it came back quicker and *quicker*.

At this point, I was desperate and willing to try anything. Some thin doctor came up with the now-infamous "Urine of Pregnant Women" diet. He had the idea of injecting the urine of pregnant women into people while keeping them on a diet of 500 calories a day. I called the American Medical Association (AMA) to find out if it was appropriate to recommend this diet treatment to our health club members.

"I *wouldn't* if I were you," said the AMA representative with whom I was speaking. "*Anyone* will lose weight if they eat only 500 calories a day, *whether they take shots or not!*" The problem was that people couldn't go on eating 500 calories a day forever, and as soon as they stopped, the weight would come roaring back.

I wrote the urine-injection folks a letter suggesting that, as long as it didn't matter, why not inject people with the urine of someone like Richard Simmons? Obviously they must not have liked my idea very much; they never wrote back.

The Lost Weekend

One Monday morning I reached the end of my rope. I hit rock bottom. It had been one of those out of control, non-stop eating weekends. When I got up that morning and started to go to work, I found that I wasn't able to button up even my largest pants.

I was terrified. Who wouldn't be? I owned a chain of health clubs and chubby weight-loss experts were *not* very popular.

What do you do if you can't go to work because you can't button your pants? Do you call in *fat*?

I was desperate. I looked around and noticed that a lot of fellow Californians I saw jogging were thin. "That must be the answer," I thought. "If you jog, you get thin." I even considered putting on jogging shoes and starting to jog east. By the time I reached New York, I reasoned, I would be thin.

If I lost all of my weight somewhere along the way — perhaps, in Kansas — I would just catch the next plane home. In my heart, I knew that I would never consider starting on that coast to coast run. Jogging wasn't the answer.

Do What You Did When What You Did Worked

Like most people, it was always a problem for me to go back on a diet that I had been on before. The first time on any diet is like an adventure, but then the monotony sets in after a few days.

This time, however, was different. I was desperate. Why not go on the *first* diet I had ever been on? That was the one that worked the best. After all, I had lost 11 pounds in the first seven days! I found the diet and started right away. I squeezed into some old sweat pants and went to the store to buy all the diet ingredients for next week's diet.

On the way to the store I saw a couple of very thin joggers and decided that this time I would *diet and jog simultaneously*. If I did both, I reasoned, the weight should come off twice as fast.

A week later, after starving myself and jogging over twenty miles, I climbed on the scale. *I had lost one pound.*

With 40 pounds to go, at this rate of losing a pound a week, I would have *only* 39 more weeks of starving and jogging ahead

of me. Discouraged, I went off the diet *and* stopped jogging. Within a few days I had gained *five more pounds.*

Thin Crust or Deep Dish?

At this point I was *really* depressed. I even considered getting out of the health club business and opening a chain of Italian restaurants. My whole life was starting to be all about my weight and my eating. I constantly thought about it, complained about it, worried about it, made elaborate resolutions about it, and got defensive about it.

Here I was, an expert on exercise, diet, and nutrition and yet I could no longer lose weight and keep it off. I was a success in every area of my life *except* weight. Overeating and extra weight invalidated all my accomplishments.

Losing weight became an obsession.

I studied every kind of diet and weight-loss plan imaginable — including behavior modification, drinking light beer and diet sodas, and eating diet foods. I talked with people who had gone to extreme measures, including popping diet pills, taking shots, and drinking liquid protein. They had meditated, been hypnotized, fussed over, pleaded with, prayed for, and starved. Some even had their teeth wired together and staples put into their ears and stomachs. *Nothing* had worked.

"They" Didn't Have The Answer

No one had an answer to the problem of how to permanently lose weight. Doctors didn't have it. Diet *experts* didn't have it. Psychologists didn't have it. Members of the clergy didn't have it. Politicians didn't have it. If anyone really had the answer, there would have been no more fat people wanting to lose weight and I wouldn't have written this book.

There are lots of psychologists, doctors, diet *experts*, and diet business owners and employees — the *Diet Industry* — who are wondering what they'd do with their time if someone let out the secret that *diets don't work.*

Diets Do Work — In Reverse!

My frustration over the failure of weight-loss diets resulted in the discovery of one of the most successful weight-*gain* programs in the country. It was based on exactly the same principles people today are using to *lose* weight.

In my health clubs were hundreds of *underweight* members who had been trying for years to *put on* a few pounds. No matter how much they were able to eat, no matter how much they exercised, no matter how many calories they stuffed into their mouths, they couldn't gain weight.

What I did with these skinny people always worked. Each was given a Special Eating Program that they were to follow exactly for three days. My Special Eating Program was simply any one of the 26,000 diets which have been published since 1920. A weight-*loss* diet. It didn't matter what kind — low fat, low calories, high carbohydrate, high protein, or high fat — just as long as it was a diet that was supposed to make them *lose* weight.

I knew that most of them would have a very hard time because they had never dieted before. I warned them that they would probably feel some side effects from the eating program. They might feel hungry, irritable, cranky, or tired, and they would want to eat things that were not on their "special" eating program.

All these skinny people swore that nothing mattered except gaining weight. They promised to follow the eating program exactly and immediately report any problems.

After the first day, the participants in the weight-gaining program came in, usually complaining of headaches, weakness, and an inability to concentrate. "Good," I would say, "that means the program is *working*."

The second and third days they would stagger in and say, "I *really* feel rotten today! It must *really* be working, huh?"

These skinny people had never been on a weight-loss diet and did not realize that they had been put on the very same, popular, well-balanced, weight-loss diets that we have *all* been on.

On the fourth day, I allowed them to get on the scale for the first time since the diet started. Guess what happened? Yes, they had *lost* weight. The average weight loss was anywhere from two to seven pounds. This weight loss turned out to be a surprise to them, and they were, of course, irate. They jumped up and down and complained that I must have made a mistake. They had wanted to *gain*, not *lose* weight!

Eventually I calmed them down by letting them know that, on this program, what happened was exactly what was supposed to happen. Now they were instructed to simply return to eating the way they had before starting the diet.

They were very disillusioned by this time, but since they were going to return to normal eating anyway, they readily agreed.

Well, the same thing happened to them that happens to overweight people. These *underweight* people not only gained back the weight they had lost, *but also put on a couple of extra pounds.*

They were *thrilled.* For the first time in their lives, they had been able to gain weight in a short period of time. When their weight gain leveled off, I put them back on the same diet for another three days.

What happened? Right! They again lost weight. Strangely enough, though, *not as much* as the time before. The average weight losses the second time were only one to five pounds, even though the *same* diet was followed exactly the *same* way for the *same* amount of time.

These skinny people began to lose their fear. They were beginning to understand. Once more I would take them off the diet, and once again they would gain back the weight they lost — *plus some.*

Over and over, I would put them on the same diet. Eventually they *didn't lose any weight at all while on the diet.* But, when I took them off the diet, they gained. I kept doing this — one step backward, two steps forward, until they gained all the weight they wanted.

Do you see the irony in this? Anything familiar about it? Does it sound like the story of *your life*?

Sometimes a strange thing happened to these formerly underweight people. I warned them before they started that, once I got them going, they may not be able to stop the weight-gain process.

They would laugh and say they would cross that bridge when they came to it. When they came to it, it wasn't so funny.

You see, diets *do* work. They work in *reverse*. Weight-*loss* diets make most people *gain* weight in the long run. They're the *best* method for gaining weight ever discovered. Just ask people who have dieted over a long period if they don't weigh more today than they did the day that they went on their very first diet. Most will say *yes*.

The Revelation

One day, I saw in a flash exactly what was wrong. For over twenty years I had been studying *fat* people, trying to find out how to make them thin.

The answer was so simple, I couldn't believe I hadn't thought of it before. *What I should have been doing was studying* ***thin*** *people to find out how they stayed thin!* Thin people must know something we don't *know* and they must do something that we don't *do*.

If I wanted to be rich, I wouldn't study poor people, I would study rich people. If I wanted to be thin, I shouldn't study fat people, I should study thin people.

Thin people were the ones with the answers. Thin people were the ones who were successful at what we were trying to do.

I wanted to know everything there was to know about *naturally thin* people, the ones who never gave a thought to their weight. Those lucky souls who could eat anything they wanted and stay thin without the slightest effort. What did they do that we didn't? What secrets did they know?

I wasn't interested in *artificially thin* people, the ones who had to struggle to keep themselves that way. You know the type. The ones who were always worrying about their weight and living on carrot sticks. Their compulsive behavior drove people around them crazy and was not the way I wanted to live.

I also wasn't interested in thin people with high metabolic rates. Some of *those* people could eat a horse a day and still not gain weight. I wanted thin people with normal metabolisms, like most of us.

The World of Thin

I began a journey into the world of thin. I sought out thin people and studied them. I talked to them, observed them, asked them questions, and watched them when they weren't looking.

At first it was tough going. *Naturally thin* people didn't have the slightest clue as to what they did. When asked, they would look at me as if I were crazy. They would come up with dumb answers like, "I probably eat less"; or, "I exercise some times"; or, "All you have to do is push away from the table."

"Diet veterans" can go to a smorgasbord and tell you exactly how many calories and fat grams are in everything there. They can compare the pie with the cake; the fish with the meat; the salad with the soup. Some of them even know how many calories are in a single leaf of lettuce or one tablespoon of cottage cheese. Diet veterans are convinced that this information is necessary for successful weight loss.

Naturally thin people are ignorant of such things. *Naturally thin* people never think about how many calories they burn off by running around the block — *they don't care.*

Naturally thin people were not able to tell me anything about being thin or how they stayed that way. However, I wasn't going to give up. I kept looking for the secret of being *naturally thin*, and finally I found the answer.

The Secrets of "Naturally Thin" People

The secret to being *naturally thin* is amazing in it's simplicity. These are some of the things I discovered:

- In studying over 10,000 people in the last 38 years — I found that being *naturally thin* is a natural state for everyone.
- Losing weight can be as easy and as natural as gaining it.
- *Naturally thin* people do four simple things that overweight people don't — and they *never* diet.
- There are reasons diet veterans gain weight and can't lose it.
- Without effort or struggle, anyone can become thin naturally and have fun in the process.

The "Thinking Person's" Guaranteed Weight-loss Program

Once I had learned the *secret* of *naturally thin* people, I lost my weight and kept it off without dieting. Thousands of people with whom I shared the secret, in my **Diets Don't Work** seminars, did also.

A special woman named Leah lost 40 pounds after attending one of my first Diets Don't Work seminars. I fell in love with Leah and married her. She has stayed naturally thin for the last 18 years.

The people attending my seminars learned to think like *naturally thin* people, feel like *naturally thin* people, and behave like *naturally thin* people. They eat real food now, not diet food. They know that if they want ice cream, a thousand carrots sticks won't satisfy them.

They don't have to think about weight anymore. They feel happier, healthier, freer, and more energetic than ever before. There are experiencing a joy and rightness about living now, as if they had discovered some fountain of youth. What they learned about being *naturally thin* has enhanced every other area of their lives.

Showing you how to become *naturally thin* is the purpose of *DIETS DON'T WORK*. It is my purpose to *end weight as a problem in your life forever.* However, there's a lot more to this book than just taking off pounds.

DIETS DON'T WORK is not just pages of do's and don't's. *It is about a new way of living. It is a new way of thinking about food and about eating that makes "fun" your primary goal and takes off pounds in the process.* If you practice this *naturally thin* way of thinking, feeling, and behaving, you are *guaranteed* to become *naturally thin.*

After you develop the *naturally thin* mentality, you can then do all those things you were going to do *after* you lost weight.

A woman named Susan, from Houston, wrote:

I never realized how much time I spent thinking about my weight problem. When I first started thinking like a naturally thin person, it was as if my mind went blank. I no longer had

to think about losing weight or eating. Instead, I decided to start planning my promotion, which I received exactly two months after the seminar. Learning to be naturally thin was like discovering a whole new world of thinking. I had all this extra time and energy to live life, to do the things I'd always wanted to do, instead of dwelling on the weight problem over and over again.

Searching for the Answers That Will Work For You

I've found through my seminars that everyone is in a unique situation with regard to their weight. I have laid out *DIETS DON'T WORK* so that *you* will learn how to become *naturally thin* through your own personal insights and discoveries.

Weight is not the problem — it's the mentality behind it. Get rid of the Diet Mentality and the weight will come off by itself, as quickly and as naturally as you gained it.

Chapter

2

Why Diets Don't Work: The Diet Mentality

The Diet Mentality

Dieting not only fails to solve the problem, it makes it worse by producing what I call the *Diet Mentality*. The Diet Mentality has come about because we were raised in a society that believes that weight-loss diets work. The majority of people still believe that the most important ingredient to losing weight is to go on a weight-loss diet.

As you know from personal experience, dieting to lose weight produces absolutely no permanent, positive results for most people. In fact, weight-loss diets wind up making most people feel worse about themselves and in the long run can do more damage than good.

The person with a Diet Mentality is addicted to the idea that weight-loss diets work. This addiction stays with the dieter despite the fact that they have *never* been able to lose their weight on a diet and keep it off.

You will soon discover a whole series of weight-loss rules, slogans, myths, and concepts that are part of the Diet Mentality that have kept you from losing your weight permanently.

It's starting to sound even worse than you thought, isn't it? Well, you're right. Dieting to lose weight is akin to throwing gasoline on a fire to put it out.

Why does this happen? Why don't weight-loss diets work? During my research over the last thirty-eight years I've discovered some very basic reasons. Perhaps one or more will seem familiar to you.

Metabolism

Weight-loss diets lower your metabolism. When the amount of food your body has been receiving drops below the amount of food it requires, your body figures that the planet has temporarily run out of food. Your metabolism (the rate at which your body burns food) slows to keep you from starving to death.

The problem is that when you go back to normal eating, your metabolism does not pop right back up to where it started. It moves up very cautiously. *Some people have dieted so often that they can actually starve themselves and not lose any weight at all.*

Deprivation

Anything human beings are deprived of, they become obsessive about.

Diets are supposed to make you think less about food, but just the reverse happens. When we start on a weight-loss diet *we begin to think about food all of the time.* We even have dreams about eating.

A key element to the Diet Mentality is the mechanism of self-deprivation that it sets up in the dieter's mind. The deprivation comes from *not* having the foods you want to eat, or the life *you* want to lead.

Fat people have already restricted their activities. They don't go to the beach, don't apply for the job they really want, don't participate in sports, and usually avoid social gatherings. Constant dieting only adds to those restrictions. It isolates them further from the mainstream of life.

Now they can't go on a picnic or to parties or out to lunch with their co-workers, can't have popcorn at the movies or birthday cake at the office. Left out and deprived because of their weight, they feel even more restricted because they're on a diet.

It's like closing off the rooms of a house one by one until only one room is left — a small, cramped space that feels like a prison. Over time this kind of deprivation and isolation can only add another negative dimension to the Diet Mentality, sapping all the vitality out of life.

It's crazy to think the stifling state of mind of the Diet Mentality could produce positive results. No wonder people have to psych themselves up for a diet.

The Vicious Cycle of Failure

You go on a diet to lose weight. At best, you have only partial success before you quit dieting, and then you gain the weight back. You get angry at yourself, feel guilty or ashamed because you failed, go on another diet, and the cycle is repeated.

You start to think of yourself as a failure. You don't dare stop dieting. If it's this bad while you're dieting, think how awful it would be if you stopped! The anxiety becomes so intense that you find yourself overeating or going on a binge to cope with it.

Most of your time is spent worrying about what you're eating, what you're not eating, how your clothes look, how many pounds you might or might not lose, how many calories or fat grams are in this or that food, and how you certainly should exercise more.

After a while every thought begins to relate in some way to your weight — *and the whole process is a negative one*. No matter how motivated you become, how strict you are on yourself, how hard you try, the outcome is always the same — failure.

The trouble is that when you are overweight, you take this kind of failure personally. You use the failure to:
- lower your self-respect,
- stop trusting yourself, and
- to beat yourself up.

It's very difficult to succeed at anything, especially dieting, with such negative behavior.

Losing Weight is Grim and Painful

To lose weight you have to be serious. Grim is even better. It's definitely not fun! Also, suffering is good. In order to lose weight you must believe that pleasure is to be avoided at all costs.

The Faster, The Better

If the diet doesn't promise a 14-20 pound weight-loss in two weeks, it's not worth following. Don't worry about keeping the weight off, just get it off!

Everyone Knows Better Than You

Let *everyone* vote on how much you should weigh — the insurance companies, your parents and friends, your boss, all the fashion magazines, and especially your mate. Consult with doctors, psychologists, psychiatrists, physical-fitness workers, and exercise instructors. After all, they're the experts!

Certain Foods Make You Fat

If you want to be thin, all you have to do is eat all the non-fattening foods. The Diet Mentality keeps you from seeing that *the reason you are overweight is that you overeat*. Even if you do acknowledge overeating as the source of your weight gain, you will believe that the solution is under-eating (starving).

Misplaced Responsibility

This element of the Diet Mentality gives you the illusion that you're no longer responsible for a basic human function — eating. The diet gives you something else to blame for your weight problem — the *diet* didn't work.

When you go on *Dr. X's Famous Diet*, you give up your power to choose when, what, and how much you're going to eat. The diet also carries with it the infuriating feeling that you're two-years-old again and someone else is in control of what goes into you mouth.

When you go off the diet, you do so with the attitude that you can't be trusted with food. If you can give your power away to Dr. X, you can now just as easily give it away to Sara Lee and Baskin Robbins — it's the flip side of the same coin. Every time you go on a diet and then go on a binge, you reinforce the pattern of placing the responsibility elsewhere.

This dieting and binging is a pattern that contradicts a basic truth: *you are responsible for what goes into your mouth.* How can you ever hope to solve a problem if you believe that someone else is responsible? You're defeated before you start. Obviously you have no control over anyone other than yourself. Only when you're clear about who is responsible for your weight will you have the power to master it. The Diet Mentality denies you this choice.

Treating the Symptoms Rather Than The Cause

What dieting can *never* do is bring to light the things that cause people to put more food into their bodies than their bodies need in the first place. *Why* you overeat, rather than the activity of overeating, is truly the source of the problem.

What stimulates people to overeat? In my seminars I've found that the cause is unique to each person. Until that cause is brought to the surface, examined, and dealt with, the pounds will *keep* coming back no matter how many diets a person goes on.

No Way Out

If you're feeling hopeless right now, you're right — it *is* hopeless. Now might be an appropriate time to open a window, stick your head out, and yell repeatedly at the top of your lungs (with apologies to Paddy Chayefsky), *"I'M MAD AS HELL AND I'M NEVER — EVER — GOING TO DIET AGAIN!"* You'll begin to feel better almost immediately.

Weight-loss diets will never work for most people. *You*, however, are not hopeless. You've just been using a *method that doesn't work* and then blaming yourself for your lack of results.

Despite the fact that the Diet Mentality makes you *less happy* and *more fat*, it persists. Though they have worked for very few, most people still insist that weight-loss diets are the only way to lose weight.

You've heard it over and over again: *"All* an overweight person has to do is eat less and exercise more. If they can't do that, it's their own fault they're fat."

Now that you've started to take a comprehensive look at how overweight people are controlled by the Diet Mentality, you should begin to see how the Diet Mentality keeps you stuck in a downward spiral. It's as if all you wanted to do was to go to the house across the street, but you kept going out to the airport to get there. Planes don't fly to the house across the street. *You can't get there from here.*

You've probably heard the saying, "Success breeds success." Many books have been written on the subject of motivation, and they've all come to one conclusion: you *cannot* motivate people with negativity and failure. You have to build on successes and positive results.

The Diet Mentality is overwhelmingly negative, self-deflating, and stifling. It has turned losing weight into a punishing ordeal that never produces the desired results. Even worse, the Diet Mentality strips us of our dignity and mastery over our bodies by implying that we are weak or defective because we can't make weight-loss diets work.

You <u>Can</u> Get There From Here

Before you can reach any goal, it's a good idea to start with where you are *right now.* The following exercises will help you have specific insights. Whatever you do, don't use any of the information you gather as a tool to beat yourself up.

This is a fact-finding mission only. Your purpose is simply to tell the truth about *where* you are now and how you *feel* about it. Please take the time to do the exercises carefully and experience what you feel as you're doing them.

Exercises

Don't hesitate to write in this book. As your personal workbook, it's meant to be written in. It's yours and yours alone, a private journal of your progress toward becoming a naturally thin person.

I cannot stress enough how important it is to do each and every exercise as you come to it. This book is specifically

*designed to recreate the experience of the **Diets Don't Work** seminar and takes you through a proven step-by-step process of personal discovery and revelation. Only when you are truly willing to look at yourself, get specific, and take the time and energy to do each exercise, will you be ready to discover your personal path to being naturally thin.*

When you answer the questions and fill in the blanks in this book, just write anything that occurs to you no matter how silly it may seem. When you go back and read your answers you will be amazed at the insights you discover. The answers to becoming naturally thin are inside of you. Let them out.

1. You will need access to a tape measure and a scale to complete this exercise.

My present "morning" weight is _175_

My present "night" weight is _____

I wear size _14_ pants

I wear size _12-14_ dress (or coat)

My measurements are (measure the largest part):

_____ hips

_____ waist

_____ abdomen

_____ upper part of right arm

_____ upper part of right thigh

2. Stand in front of a mirror. Say the following sentence out loud, as if you were merely stating a fact:

"I, (say your name), weigh _____ pounds (night weight) and wear size _____ pants (or dress)."

What did you think and feel while you were doing this exercise? What did you *hear* in your voice?

 3. Stand in front of a mirror and say the same sentence again. This time, look yourself in the eye and say it *as if* you were the one who made your body that way. You made your body this way, and it is *exactly* the way you want it to be. Say it as if you'd done it all by yourself, for some *essential* reason.

 4. Complete the following sentence, being as specific and thorough as you can:

"I've wanted to lose weight since ___*14*_____

_____."

 Write down, as fully and specifically as you can, the answers to the following questions. Take some time to think about your answers and elaborate as much as possible.

 5. These are the *thoughts and feelings* I frequently have about being overweight:

6. These are some of the good reasons I've wanted to lose weight in the past:

a. _____ *Health Reasons* _____

b. _____ *Look Better* _____

c. _____

d. _____

e. _____

7. These are a few of the most memorable ways I've tried to lose weight in the past:

a._____

b._____

c._____

d._____

e._____

8. What has happened in the past when you've gone on a diet? (Did you lose all of your weight and then gain it back? A few pounds? None at all? What specifically caused you to fail?)

9. What do you now believe is the problem? Is it you, or is it the diets you've tried?

10. What has been your *own* experience with the Diet Mentality? Write short descriptions of what happened when you got hooked into going on a weight-loss diet, and tell how you felt before, during and after the diet.

11. If you still believe that a properly structured diet *could* work for you, why?

If you came up with reasons like, "Maybe someday I'll find a better diet," or "Maybe someday I'll get more will power," then ask yourself if you really believe that. Are you willing to wait that long?

12. Right now, without knowing any more than I do, these are the steps I think I *should* take to begin losing weight:

a. *Limit amount of food I eat*

b. *Exercise on a regular basis*

c. _____

d. _____

e. _____

13. Why do you think weight-loss diets continue to be popular with overweight people who have been on all the diets and are still overweight?

14. Are you willing to give up on weight-loss diets and try something different that makes sense, even if it means *admitting* that you've been wrong in the past?

15. If you woke up tomorrow morning with a *naturally thin* body, what *three* new things would you do?

a._____

b._____

c._____

As you think of more new things you would do in your *naturally thin* body, continue to add to this list.

Thank you for taking the time and energy to do these exercises. Each time you're willing to examine yourself and be honest about your relationship with your weight, you make progress toward becoming a *naturally thin* person.

Chapter

3

End Weight As A Problem — Forever

The Challenge

At this point you are standing at a fork in the road. You are at a unique juncture in the history of weight loss. Up to now people have been viewing weight loss from the point of view of the Diet Mentality. All the established assumptions, points of view, and attitudes claim that the only way to lose weight is to go on a weight-loss diet and exercise.

What makes the Diet Mentality approach so frustrating is the mounting evidence that it doesn't work. In addition, the Diet Mentality point of view has created resignation, hopelessness, and anxiety for the majority of people who have responded to it's call.

This book creates a new way of thinking about weight-loss — it focuses on what *does* work rather than what doesn't work.

For example, suppose the stereo system you want costs $3,000. Which one of these approaches would work best:

– Worrying, fretting, and moaning about not having $3,000? or...

– Concentrating on what you need to do to raise $3,000?

The second would be the obvious choice. To be successful, you have to let go of the first approach in order to make the second approach possible. It's the same with weight-loss.

Look at your own experience and begin to realize that weight-loss diets are *never* going to work for you. Then, you will be able to move on and begin to create a *naturally thin* approach to losing weight.

End Weight as a Problem — Forever

We're still pioneers on this journey. Someday the world i going to come to the realization and admit that diets don't work. There will be newspaper stories, magazine articles, and scientific papers about it.

Even after the first edition of this book was published in 1982, and over 600,000 copies have been sold, the world is still operating from the mentality that the way to lose weight is to go on a weight-loss diet. Remember, the world used to operate from the mentality that the world was flat — until Columbus made his breakthrough discovery.

You Have To Do It <u>Your</u> Way

DIETS DON'T WORK has been carefully designed to let you produce specific and measurable results. It's intended to give you the same experience of being a *naturally thin* person that people had in my *Diets Don't Work* seminars. It's your personal workbook, a private diary that's yours and yours alone.

The exercises in each chapter are for your eyes only, unless you choose otherwise. You will discover:

- How the unwanted pounds got there in the first place
- What has prevented you from taking off your unwanted pounds
- What it will take for you to become a naturally thin person

Everyone who reads *DIETS DON'T WORK* will discover different things about themselves. Your insights and realizations will be unique to you. Having these insights won't take off the weight, but they will allow you to see how your weight got there and why you haven't been able to lose weight or keep it off.

In other words, reading *DIETS DON'T WORK* may not prevent you from going on a few more eating binges, but it will help you find out what causes you to overeat and what you can do about it.

You will choose for yourself whether you want to live and eat like a fat person or a *naturally thin* person. You will discover that you have never really been in a position to make that choice before because the Diet Mentality has obscured your thinking.

Like a pair of colored glasses, your Diet Mentality colors whatever you see. The Diet Mentality twists your thinking and you fail. Then, not only do you fail, but you blame yourself for the failure.

Another problem is that you probably have no memory of what it feels like to be *naturally thin*. By the end of *DIETS DON'T WORK*, you will have had a direct experience of being *naturally thin*. Then you will know what choices are possible and which will work for you.

Your Best Friend

One of the most devastating things about the Diet Mentality is that it encourages you to hate yourself and your body and to treat yourself accordingly. The *DIETS DON'T WORK* approach to losing weight is to be kind, positive, and gentle with yourself. Being overweight is not a crime. The person inside your body, the real you, is a capable and lovable person. You may not presently believe that you are, but I invite you to put self-recrimination aside for now.

Begin acting in a more loving way toward yourself. The Diet Mentality indoctrinates us with the idea that harsh discipline has to be used to get results. You are going to discover that just the opposite is true.

Begin treating yourself as if you were *already naturally thin*. Begin to take care of yourself as if *you really cared about you*.

There are probably hundreds of ways you deprive yourself or treat yourself like a second-class person. In the next exercise you get to *play the part of your best friend*, someone who cares and knows everything about you.

I'm going to ask you to make lists of all the things that an imaginary best friend could do for you. Things that would make you feel cared about and appreciated.

These are extremely important exercises. Your answers will be referred to again in a later chapter.

I've divided the following list into four categories with space for five items under each category, and included two exercises on incompletions.

Exercises (30 minutes)

1. These are five *personal* things my imaginary best friend could do for me that would make me feel cared about:

a._____

b._____

c._____

d._____

e._____

2. These are five things my imaginary best friend could do for me *at work* that would make me feel cared about:

a._____

b._____

c._____

d._____

e._____

3. These are five things my imaginary best friend could do for me *around the house* that would make me feel cared about:

a._____

b._____

c._____

d._____

e._____

4.These are five things my imaginary best friend could support me in doing for *my body* that would make me feel cared about:

a._____

b._____

c._____

d._____

e._____

Thank you for taking the time and energy to write out your answers. Over the last twelve years I have met thousands of people who had read *DIETS DON'T WORK*. Every one of those who had lost all of their weight and kept it off had *written out the answers to the questions in their books.* Most of the people still struggling with their weight, may have thought about

the answers, but never took the time to write their answers down. It is their Diet Mentality that keeps them from writing out their answers.

Writing creates results for the reader; just thinking about the answers does not. I know how difficult it is to write in a book after all the years of being told not to. However, this book is the logical place to keep this information. These *written* answers will be invaluable when you come back to review them.

Do not think too much about your answers. If you get stuck, just keep writing. Make something up. You will discover when you go back and read over what you have written that some of your made up answers may begin to make a lot of sense. Lighten up a little bit. This is not a test.

If you are reading the book with someone close to you such as your spouse, you might want to use the same book. You should each use a different color ink to keep your answers separate. Reading the book together is a great way to support each other in being *naturally thin*.

If you need more space for your answers than provided in the book, use additional paper and staple it to that page. Do not let the limited space in this book limit your writing.

Do this next exercise without worrying about how each item is going to get done. Just write as fast as you can. Break down each task into separate steps if it makes it easier for you.

List 100 things you have left undone (incompletions) and be willing to complete them within the next three months. *These are things that you began but did not finish; that you thought about doing but did not do (letters not written, buttons not sewed on, calls not made, etc.):*

1. _____

2. _____

3. _____

4. _____

5. _____
6. _____
7. _____
8. _____
9. _____
10. _____
11. _____
12. _____
13. _____
14. _____
15. _____
16. _____
17. _____
18. _____
19. _____
20. _____
21. _____
22. _____
23. _____
24. _____
25. _____
26. _____
27. _____
28. _____
29. _____
30. _____
31. _____
32. _____
33. _____
34. _____

35. _____
36. _____
37. _____
38. _____
39. _____
40. _____
41. _____
42. _____
43. _____
44. _____
45. _____
46. _____
47. _____
48. _____
49. _____
50. _____
51. _____
52. _____
53. _____
54. _____
55. _____
56. _____
57. _____
58. _____
59. _____
60. _____
61. _____
62. _____
63. _____
64. _____

65. _____
66. _____
67. _____
68. _____
69. _____
70. _____
71. _____
72. _____
73. _____
74. _____
75. _____
76. _____
77. _____
78. _____
79. _____
80. _____
81. _____
82. _____
83. _____
84. _____
85. _____
86. _____
87. _____
88. _____
89. _____
90. _____
91. _____
92. _____
93. _____
94. _____

95. _____
96. _____
97. _____
98. _____
99. _____
100. _____

This is how I would feel if most the above items were completed within one year of finishing this book:

The "Fat" and "Naturally Thin" Persons Inside You

Before we go on to Part Two, *Dismantling The Dysfunctional "Diet Mentality,"* I want to prepare you for a battle that will be raging while you're reading this book. It will be a battle between the *fat person* and the *naturally thin person* inside you. They represent two parts of yourself, and each has a voice.

The *fat person* is the one who says things like:

"Go ahead, eat the rest of that candy, it will make you feel better."

"You were bad to eat that piece of pie."

"You've already blown it, you might as well finish off the ice cream, too."

"Let's wait until Monday before we start to think about losing weight."

"A neat person like that wouldn't be interested in spending time with a *fat person* like you."

Up to now that *fat person* has been winning. That *fat person* has had a lot of experience and is an expert in the Diet Mentality. That *fat person* knows exactly what to say to defeat you.

As you've read along in *DIETS DON'T WORK*, that *fat person* is probably going to become more and more uncomfortable and restless. You're blowing that *fat person*'s cover with every page you read. When you get that *fat person* out into the light of day, you'll see that you don't have to let the Diet Mentality run your life.

Fat person is not going to give up without a fight, though, so be prepared. Remember that the more screaming and squirming the *fat person* does, the closer you are to exposing him; to finding your own answers; to trusting yourself; to letting go of your negative self-image; and to being free of the Diet Mentality.

The next part of *DIETS DON'T WORK* will really bring out that negative voice. We'll take a look at what you're up against in losing weight and letting go of the Diet Mentality. You'll get a chance to be *naturally thin* for a day, and by the end of Part Two, you'll choose how you want to live the rest of your life.

Part Two

Dismantling The Dysfunctional "Diet Mentality"

DIETS
DIETS
DIETS
DIETS
**DIETS
DON'T
WORK**
DIETS
DIETS
DIETS
DIETS

Chapter

4

The Real Reasons
You Are Overweight

Your Worst Enemy

This chapter is going to be a difficult one. We discovered that 30 of every 100 people who started reading *DIETS DON'T WORK* have quit at this point. You are among the 70% who have stayed with it, who have the courage and commitment to keep going. It will take even more of your determination to get through this section.

We're going to look at some of the ways you keep yourself overweight. You're probably somewhat familiar with why you stay overweight and why you eat. You may even realize that most of your eating has nothing to do with giving your body the fuel it needs. As you read this chapter, you'll discover some exciting new information.

When people begin to examine what they've done in the past in relation to food, they have a tendency to trigger the Diet Mentality and become grim. What you have done in the past was appropriate or even necessary. In any case, you had to pass through that phase to get to where you are now. The past is past.

DIETS DON'T WORK is designed as a tool for learning how to be *naturally thin*, not a whip for beating your overweight body. Let this information be your servant, not your master. Allow *DIETS DON'T WORK* to support and inspire you.

You may see things about yourself that you don't particularly like. So what? You need that information in order to transform your Diet Mentality relationship with your body.

Before you can repair a watch, it helps to understand why it's broken. Before you can dismantle the Diet Mentality and take off your weight once and for all, it's important to understand how the weight got there and what makes it stay.

People often have habits that aren't to their benefit. You already know some of those habits that center around eating. You have also demonstrated that you have the courage to examine and tell the truth about those habits. Only after recognizing what habits hold you back, can you begin to change them.

The purpose of *DIETS DON'T WORK* is not to make you a smart fat person or a grim fat person, but to put an end to weight as a problem — forever. Being grim is part of the Diet Mentality and promotes negative attitudes, inviting the predictable cycles of weight loss and then subsequent weight gain.

Many people think that they have to be tough on themselves to keep themselves in line. "Don't do that," "Don't eat that," "Keep depriving yourself until you lose all your weight," are all hallmark slogans of the Diet Mentality. No matter how fast or far you have gone on a weight-loss diet, it's never been fast or far enough for the Diet Mentality.

Why go on devoting your life to negative behavior that only makes you miserable? If you are gentle with yourself, you'll make it easier for the *naturally thin* person to surface. You begin to water the flowers instead of the weeds.

When you recognize some of the reasons for overeating, your tendency will be to think, "Oh, no, I'm even worse than I thought." It's not necessary to be that hard on yourself. Just *notice* what you're doing. You have simply chosen those habits and you can change them.

There are worse things in life than eating for the wrong reasons. Reasons are neither positive nor negative in themselves, but only in so far as they support or hinder you in accomplishing your goal — losing weight and keeping it off.

The Reasons Why Overweight People Overeat

Sometimes I think overweight people are the most creative and imaginative people in the world. Every time I led a *Diets Don't*

Work seminar, someone came up with a new answer to the question, "Why do you eat?." As you read through this list of reasons for eating, check off the ones you have used in the past. If you come up with other examples, add them in the space provided.

1. **Warm Fuzzies**. Nothing in the world is as comforting as eating. Food doesn't talk back to you. Food doesn't withdraw its love. If something upsetting happens, you have a problem in your relationship, or if you feel depressed for no particular reason, eating eases the physical or emotional pain.

Yes ✓ No __

2. **The Connoisseur**. You love the taste of good food. Your finely honed palate is always on the prowl. What if you miss eating something special?

Yes ✓ No __

3. **The Reward**. You were so good today that you deserve to eat. You worked hard, did such a good job at the office or with the kids. Time to do something for yourself. Reward yourself. Maybe you've stuck to your diet all day long, and now it's 9:00 p.m. Surely you deserve a reward for that. You've overcome some great trial, weathered some storm. Your car battery was dead this morning and you had to have it recharged — that ought to be worth at least a couple of cookies. You spent your whole lunch hour talking to a friend who was depressed. Don't saints have to keep their strength up? You cooked the meal. *Who has a better right to eat it?*

Yes __ No __

4. **The "Starving Children" in China.** "Don't you dare leave a scrap of food on your plate when there are starving children in the world." You've heard it since you were two years old. (Parents must get reports each morning about locations in the

world where the children are starving that day.) The "starving children" is a tape that plays in almost everyone's mind, consciously or unconsciously. You're not only selfish and spoiled, you threaten world prosperity and increase world hunger if you don't eat that last bite.

Another version of the "Starving Children" in China is the "Clean Plate Club." In Clean Plate Club families, the only children allowed to leave the table or have dessert are those that clean their plate. The other children had to stay at the table until they managed to stuff every last piece of food on the plate into their bodies.

If you cannot leave food on your plate, you may not be thinking specifically about the Starving Children in China or the Clean Plate Club, but you still believe that an empty plate is *good* and throwing any food away is *bad*.

Yes __ No __

Carol, who took the Diets Don't Work seminar in Oakland, told a wonderful story about the Starving Children habit. She was at a breakfast meeting where someone had spread out dozens of assorted pastries and donuts on a huge platter. As she devoured one pastry after another, a very thin man sitting across the table, took a pecan roll, put it on his plate, and sat nibbling only the parts off the top — the pecans, butter, and caramel.

At the end of the meeting, the pecan roll was just a lump of dough, with all the sweet, crunchy parts eaten off — much to Carol's dismay. As the thin man was leaving, she asked him if he was going to finish the rest of his roll. Smiling, he replied, "I only like the top."

Was leaving the rest of the pecan roll on the plate any more of a waste than Carol's stuffing all those pastries into her body? In that moment, Carol experienced a revelation. She realized that putting food in your mouth doesn't prevent it from being wasted. World hunger had not suffered because the thin man hadn't eaten all of his pecan roll.

5. *Slogan Eating.* This habit is closely related to the Starving Children in China idea. Slogan eating comes from those bits of wisdom handed down from generation to generation at the dinner table. For example: "Take all you want, but eat all you take." "Don't waste your food." "Food costs money, you know." "You'd better eat it before it gets cold." The person who said it might not be standing over you any more, but the slogans remain.

Yes _✓_ No __

6. *Bargain Eating.* Someone else is paying for it, so why not? You might as well have the soup and salad *and* the dessert. No one takes you out to dinner every day, so you should get as much out of it as you can.

You found this wonderful little market or restaurant where the prices are so cheap, who could pass up such a deal? Take the eclair. Take three! It's cheaper than *one* anywhere else..

How about those restaurants that have all-you-can-eat night? You didn't really want to go, but someone dragged you there. As long as you paid for it you have to get your money's worth, even if that means three or four helpings.

The *free* meal is the most seductive. The free meal on an airplane, free samples in the supermarket, or that wonderful buffet at a party. If it's free — you've *got* to eat it. There aren't many opportunities to get something free, now is your chance!

Yes _✓_ No __

7. *Procrastination.* You have a project to do. You lay out all your materials on the desk. Then you decide you need something to eat. Next thing you know, you're drifting toward the kitchen or the snack bar down the street. Some people procrastinate by staring into space, biting their fingernails or watching television. People with weight problems procrastinate by eating.

Yes _✓_ No __

8. *TV Eating*. Sharon, who took the Diets Don't Work seminar in Los Angeles, said that she never watched television without eating, and never ate at home without watching television. She didn't have a kitchen or dining room table; only a tray in front of her TV. Eating and watching television, were completely associated.

When Sharon's television was not working for a week, she lost five pounds. "I just didn't have the desire for food unless I was watching television," she said in the seminar.

Yes __ No __

9. *Scarcity Eating*. Grab it now, because if you don't, someone else will. This is your last chance, you might not eat again for hours. There will never be another dessert like this one. Better eat it now while you can.

Yes __ No __

10. *They Made Me Do It*. Your friend insists you try his favorite restaurant. You don't want to offend your host by not finishing dinner, and it's impolite to refuse a second helping.

You just can't say no to people who offer you food. You don't want to be rude. Being liked or getting approval, at the time, seems more important than losing weight.

You were going home after the movie, but your friends insist you stop for pizza and beer. When everyone is too full to eat the last piece, you finish it off.

Your mother laid out enough food to cater the Super Bowl. She made it all for you. You can't hurt her feelings by not eating it.

Yes __ No __

11. *Souvenir Eating*. You are on a vacation and you may never get back to that cute little restaurant by the ocean. You eat as if you were collecting souvenirs, except when you get home you can't put the food that you ate on the mantle — it's already on your hips!

Instead of enjoying the sights on your trip, you act like a giant caterpillar in a horror movie, eating your way through your trip, mile by mile.

Yes __ No __

12. *Health.* You're bigger, so you need to eat more, right? You could become malnourished. If you don't eat, you will get sick and have to go to the doctor. You even might become anorexic.

"Feed a fever, starve a cold." Or is it the other way around? Be safe — feed both!

If you stop eating, you might start smoking again. A few pounds is better than dying of lung cancer.

"I only ate junk food today, so I'd better eat something nutritious to balance it out."

Yes __ No __

13. *Preventive Eating*. If you don't eat now, you will be hungry later. Who knows if there will be any food — so have another helping.

Better eat before getting on a plane. Everyone knows that airline food isn't that good and the portions are so small! You could be trapped 30,000 feet in the air with nothing to eat for hours. Most people have never missed a meal on a plane and there have been no reports of anyone starving to death on a plane.

Yes __ No __

14. *Transition Eating*. Eating divides up the day. It gives you the momentum to do what's next. Coffee and rolls mean halfway to lunch. Lunch is the halfway point through the workday. Dinner means it is time to relax. Eating is a way of letting you know it's time to go on to the next part of the day.

Yes __ No __

15. *Pre- and Post-diet Eating*. Monday morning you're going to start the new weight-loss diet and *make* it work this time, even if it kills you. Sunday night is the condemned dieter's last meal. Eat up all the temptations. You're going to start being good — tomorrow morning. So, what does it matter? You'll be taking it off next week anyway.

You've just come off your last weight-loss diet. A whole week spent picking at grapefruit and tasteless, no-fat, low calorie food. Even the thought of what you have been eating makes you cringe. Maybe you even lost a few pounds. You have a little leeway now. You'll *never* go back to eating the same way as before the diet. Why not have just a *little* binge. You certainly deserve it.

Yes __ No __

16. *Pre- and Post-exercise Eating*. You need to keep your strength up if you're going to exercise. You could feel weak if you don't eat something. The calories will come off when you work out.

After you exercise, you feel good. You deserve to eat.

Yes __ No __

17. *Closet Eating*. You eat when no one's watching. Most of the day there are people around, looking at what you eat and passing judgment on you. You're all alone now — run to the kitchen!

You go out with friends and have nothing but a salad. You're watching your weight and they're watching you. They think you have such willpower. You can't wait to get home and be alone with your food.

Yes __ No __

18. *Grazing — The Quest For Satisfaction*. A woman named Karen, from New York, had this habit. She spent years looking for something in life that would really satisfy her. She was not getting what she wanted from her job or her relationship, so she found herself looking for satisfaction in the kitchen.

Every day Karen would open the refrigerator and stare at the shelves, searching for something that would make her happy. As if in a trance, she would stand there shoveling food into herself. Karen finally found satisfaction, but it wasn't in the refrigerator.

Grazing takes place while you are standing or moving around, just like cattle in a field. Grazing shows up a lot when you're at home cooking or late at night — or when you are out sight seeing, shopping, running errands, or just killing time. Some people graze through entire cities — block by block.

Yes __ No __

19. *Hunger Pangs*. You have that funny feeling in your stomach and it starts to rumble. Your parents told you those were hunger *pains*, and you think, "Uh-oh, better eat something quick. I'm having hunger pains!"

Fortunately, most people will never experience hunger *pains*. A hunger pain is not like having a headache in your stomach. What you are having are only *feelings* — hunger feelings!

Make a fist and look at its size. Your fist is approximately the same size as your stomach. How much food would it take to fill a space the size of your fist? How much food do you eat? Is it enough to stretch your stomach out three or four sizes?

When your stomach tries to shrink back down to its normal, natural size, it makes those funny noises and produces those feelings. Those noises can be a healthy sign that your stomach is shrinking! Hooray! You should celebrate, not work against your stomach, stuffing as much into it as you can.

Yes __ No __

In an Oakland seminar, a woman named Denise shared a story about her childhood. Her mother told her that the way her stomach worked was that the walls rubbed back and forth against each other to grind up the food. If there was no food, her stomach would rub a hole in itself!

As an adult, Denise did not remember what her mother had told her. Whenever she tried to cut down her eating, she would become frightened. She became anxious and feared that if she didn't eat, something terrible would happen. The fear of those hunger feelings was so strong that she would always eat, no matter how determined she was to lose weight.

20. *I'm Grown Up Now, and I'll Do Whatever I Want.* As children, our parents had control over everything, including the food we ate. Often that control made us angry. We unconsciously adopted an attitude of, "When I grow up, I'm going to eat everything Mom and Dad wouldn't let me have." Some people spend their lives proving that no one can tell them what or what not to eat.

Yes __ No __

21. *Unconscious Eating.* Most overweight people eat unconsciously 95% of the time. At certain times and under some situations, you eat as if you were an *automatic eating machine*.

You go to a movie and head straight for the snack bar to buy popcorn. The first bite is just wonderful. The next bite is pretty good, too. After that you become unconscious, an automatic eating machine. As your hand hits a bunch of kernels and salt at the bottom of the box, with popcorn breath you ask yourself, "Who ate my popcorn?"

Yes __ No __

22. *Boredom Eating.* You have time on your hands — what can you do? How about getting something to eat?

First, you have to think about what food you want. Then, you will need to go to the store, buy the food, and prepare it. Now, you get to sit down and eat it. Finally, you have to wash up and put things away.

Many people spend as much as four to six hours every day repeating this pattern. Eating becomes the most interesting activity you can think of to fill your day.

Boredom eating works in reverse, also. You never have enough time, so you'd better shove the food in your mouth while you can. You have so little time for yourself. At least, you should be able do *something* for yourself. What's better than eating?

Yes __ No __

23. ***Worry Eating***. Ever have one of those times when things aren't going well? You're tense and anxious. Something is wrong. It could be an upsetting time in your life. Maybe you're going through a divorce, the pressure is on at work, or you've had some other personal crisis.

Maybe you're in one particular situation that makes you nervous — out to dinner with people you really don't want to spend time with, or at a party or at a big business meeting. Rather than experience your emotions during those difficult times, you push your feelings down with food.

The problem, of course, is that the difficulties always come back, just as big or bigger than before. If you want to get rid of anxiety, all you have to do is stuff it — literally. Your motto is, "When the going gets tough, the tough eat."

Yes _✓_ No __

24. ***Creative Eating***. You love to cook and you are a *great* cook. Cooking is one of the ways you express yourself. *Someone* has to eat that marvelous gourmet meal and it might as well be you. You're also into exploring new foods and recipes. You are known for your adventurous spirit, zest for living, and for discovering the finer things in life. Eating is an exciting part of your life.

Yes __ No __

25. ***Holiday Eating***. It's Thanksgiving. Everyone overeats at Thanksgiving, even thin people. Thanksgiving wouldn't be the same if you didn't eat yourself into a stupor and had to lie down after the meal.

The Christmas holidays last longer. Thanksgiving is only for a day, but Christmas goes for weeks! Holiday parties and family get-togethers. "Eat, drink, and be merry." Candies, cakes, drinks, buffets and family dinners are all a part of the holiday season. You don't want to be a party pooper. Eating is what holidays are for — a celebration. Who ever tried to lose weight during the holidays?

Yes __ No __

26. **Energy Eating**. You need energy if you're going to face this day, let alone get through it. At night, when you're tired, you have to fortify yourself with more food to stay awake.

Energy eating also works in reverse. You feel that you have too much energy and can't sleep if you don't eat. After all, eating calms you, soothes you, keeps you on an even keel. If you don't eat, you'll be too hyper and nervous.

Yes __ No __

27. **Ritual Eating**. This is eating certain things at certain times, or under certain circumstances. Ritual eating is done day-in and day-out.

If the ritual means going across the street for a bar of candy at 3:30 p.m., you'll go get that candy even if the sky is hailing golf balls. If for some reason, you are unable to eat when the ritual calls for it, you feel tremendously cheated.

Yes __ No __

28. **Clock Eating**. It's 12:00 noon. Time to go stand in line for lunch with everyone else. Or, it's morning, the most important meal of the day. Mealtime is the time to load up your body, whether it needs it or not.

Yes __ No __

29. *Eating For Two.* You are pregnant. It's the one time in your life that you have the license to eat anything, anytime — even pickles and ice cream in the middle of the night. It's not for you, it's for the baby. Why worry now? Thin is out of the question, even though your doctor has said you're gaining too much weight. You'll lose it after the baby is born.

Yes __ No __

30. *Love Food.* Falling in or out of love often leads to eating. Eating is understandable, especially if you are falling *out* of love, or if someone is falling out of love with you. At the end of a relationship, you're unhappy, upset, anxious, confused, and hurt. You yearn for the comfort and temporary quiet that food can give you. Falling out of love is not a happy time. Now that it's over, what does it matter whether you look good or not?

The reverse of this category is not so obvious — that is, when you're falling *in* love. This would be a time to be interested in losing weight because falling in love is a happy and exciting period. However, love brings new feelings, including new anxieties. Even though you've longed to have those wonderful feelings, love can be unfamiliar and disconcerting. One guaranteed way to tone down unfamiliar feelings is, of course, to eat!

Yes __ No __

There are many more reasons people overeat. You probably know some we haven't mentioned here. The above are just a sample of some of the reasons you might still overeat.

Now take ten minutes and complete these exercises before you go on.

Exercises (10 minutes)

1. These are the reasons I eat: (You can make this exercise easier by repeatedly asking yourself, "Why do I eat?" or "What makes me overeat?")

a._____

b._____

c._____

d._____

e._____

2. These are three reasons not mentioned in this chapter that I use for eating too much:

a._____

b._____

c._____

3. These are the payoffs or benefits I get from eating for the above reasons: (Example: "I always eat too much when I'm at my mothers house because I want to avoid making her unhappy.")

a._____

b._____

c._____

d._____

e._____

4. These are the specific circumstances which are likely to cause me to overeat:

a._____

b._____

c._____

d._____

e._____

If you had trouble completing this exercise, observe yourself for a few days. Keep asking yourself these questions and write down your answers as they come to you.

Behind the Reasons for Eating Too Much: Your Personal Rules

The purpose of looking at the reasons you eat is threefold. First, to realize the extent to which you eat for your *head* rather than for your body. Weight-loss diets are never going to work. All the weight-loss diets in the world leave your head alone and hassle your body instead.

Second, when you look at the reasons why you eat, you can see the contrast between your Diet Mentality and the *Naturally Thin* Mentality. It's obvious how out of touch you are with your body.

Third, by examining the reasons you eat in detail, you'll see that there are deeper reasons — what I call the personal rules — that underlie why you eat too much.

In the ***Diets Don't Work*** seminars, participants began to see their own set of personal rules. As long as you are unfamiliar with the forces that keep you overweight, you cannot gain mastery over your weight — you'll never become *naturally thin*.

How do you discover your real reasons for being overweight? First, look at the unwanted results you are producing.

One of the rules of life is that *we always do what's most important to us*. If you want to know what your priorities are, just look at what you do.

Simply ask yourself what personal rules you have invented which cause you to act the way you do. Keep asking yourself those questions, and eventually your personal rules will become clear.

Let me give you an example. Jane, thirty-five years old and the mother of two, is trying to lose weight again. Jane wants to lose weight this time because of an upcoming wedding. This is what she has to say about being overweight.

Oh, I wish I were thin. I know I would feel so much better. Over the years I've tried every weight-loss diet under the sun, but I just can't keep the weight off. It's such a battle.

Overweight has been a problem since I was a young girl. Well, some of us are like that. My oldest daughter has the same problem. When she was young, I thought she was a cute, chubby, healthy, little girl. Now I see she's just like me, as I am like my mother. It runs in the family. My youngest child bothers me sometimes, he's so thin. I'm afraid he'll be sickly and frail the rest of his life. I tell him how lucky he is that he doesn't have to worry about weight. I always reward him when he cleans his plate; he gets a big bowl of ice cream. I should be so lucky.

Look at the following conscious and unconscious rules that are motivating Jane.

- Thin people feel better than fat people.
- Dieting is very difficult.
- Weight loss can never be permanent.
- Being overweight has always been a problem, so it will continue to be a problem.
- Fat babies are healthy babies.
- The tendency to be overweight is inherited; there is really nothing one can do about it.
- Thin people are sickly, so who would want to be thin?
- Food is a reward; clean your plate to get dessert.

Upon closer examination it is clear that Jane has many conflicting rules and attitudes about weight. These conflicts make weight loss impossible.

She's passing those same rules and attitudes on to her children. For example, she truly believes that she will always have a weight problem. Her mother has one, her daughter has one — weight problems run in the family.

Jane is also teaching her youngest child that food is a reward rather than nourishment. Most likely, her son will continue to reward himself with food as he grows older — a snack after mowing the lawn, a piece of cake after going to the grocery store.

Jane sincerely believes her personal rules and will continue to produce the results that support them. Until Jane becomes aware of these personal rules, she will not be able to evaluate them or decide whether or not to continue the cycle.

You, too, have the same choices as Jane. You can continue to remain unaware of the personal rules you have about your body and your eating — or make a conscious effort to discover what those rules are. Only if you know what causes you to overeat and stay overweight can you choose to produce different results.

The exercises below are designed to stimulate your awareness. You may discover a number of personal rules that dictate your personal eating habits. The purpose of the exercises may

not be clear at first. These exercises will function like a time-release capsule. Their effects will be realized by the time you get to the end of *DIETS DON'T WORK*.

Exercises (20 minutes)

1. What were the circumstances in your life when you first began to gain weight?

How old were you? _____

What were your relationships like?

What was your money, school or job situation?

How successful were you in school or at work?

Was there some trauma, crisis, or pressure in your life?

Provide as much detail as possible.

2. Describe in detail the circumstances that cause you to overeat today.

3. When you attempt to imagine yourself being thin, what objections come to mind? For example:
"Good mothers aren't thin and sexy."
"People might expect more from me."
"My friends or family might not like it if change."
"I'll have to do all the things I said I would do when I got thin."

4. Look back over your answers and see if you can find and underline the personal rules that cause you to overeat.

5. Look at your personal rules closely. Are they still useful or true?

6. Do your personal rules produce the results you want now?

Why Naturally Thin People Are Thin And Stay Thin

Have you ever asked *naturally thin* people why they eat? When I ask, they eye me suspiciously and say, "Is this some kind of trick question?"

When I assure them I really want to know, they look at me as if I'm crazy and say, *"I eat because I'm hungry."*

You very rarely get that answer from people with weight problems. Now you can see why. Overweight people do not eat because they are hungry.

When *naturally thin* people are hungry, they eat. They eat exactly what they want, but when their bodies have had enough, they stop. When they're not hungry, you can't force them to eat.

Overweight people are so busy eating that they very seldom get to the point of hunger. They use food to satisfy all other "hungers" — emotional hunger, intellectual hunger, even sexual hunger. They feel a craving for something and habitually assume it's for food. The problem is that those hungers are never satisfied by food.

Janet, from Houston, wrote this letter to me after her *Diets Don't Work* seminar.

I was having dinner with a naturally thin friend last night. We were discussing the weight problem of a mutual friend. My naturally thin *friend was asking me questions about what it was like to go on a binge. I tried to explain to her what it was like.*

I realized in explaining it to her, that on a binge, food ceases to be food. When I went on a binge, I would attribute all kinds of abstract qualities to food — well being, love, security, comfort, happiness. Looking back, I realize that I hardly tasted the food. It wasn't food to me anymore. It was whatever I needed at the time. Since it was only food, no amount of it would take the place of what I really needed.

The Diets Don't Work seminar completely transformed all of that for me. Food is just food now. Since the workshop, I sometimes still eat to feel better. I have been shocked to discover that I don't feel better, I just feel bloated!

Suppose you had a *naturally thin* friend who was heartbroken because she'd just broken up with her boyfriend. As she sat there crying, you reached out in compassion and offered her a donut. What do you suppose she would do? She would probably look at you, confused about what you were trying to do. She would probably ask in desperation, "But what am I supposed to do with it?"

You see, to her food is something you put into your body when you're hungry. The fuel you use to keep your body going. She doesn't connect food and problem solving. She doesn't confuse physical and emotional appetites.

At one of the follow-up sessions of the ***Diets Don't Work*** seminar, a woman named Sarah, from San Francisco, told this story:

Last week I found myself walking around the kitchen with a book in my hands. I realized halfway across the kitchen that what I wanted most was to curl up and read.

What was I doing in the kitchen? I don't even have a place to sit down in my kitchen. I got a glass of water and went and curled up with the book. I began to realize that hunger is a broad category for me. It covers the need for rest, the need for entertainment, the need for affection, the "hunger" for many things that have nothing to do with food.

Let's examine some of those hungers.

Exercises (3 minutes)

1. These are the different emotional hungers I try to satisfy with food:

a._____

b._____

c._____

d._____

e._____

2. These are the specific foods I use to try to satisfy those hungers:

a._____

b._____

c._____

d._____

e._____

Chapter

5

Why You Haven't Been Able To Get (or Stay) Thin

The last chapter described many of the reasons overweight people eat. This chapter will look at common reasons for losing weight, and will show you what those reasons have to do with *staying overweight. DIETS DON'T WORK* will continue to reveal why the weight-loss game has been a puzzle with no solution.

The Best Reasons for Losing Weight

As you read this section, note if you use any of the following reasons for losing weight. If you think of any other reasons, write those underneath your *yes* or *no* answers. Be as specific as possible. Discovering those hidden reasons, that haven't worked, will make it easier to become a *naturally thin* person.

1. *To Look Better*. No denying it — you would be more attractive without the weight. You're okay now, but without those pounds you would look wonderful.

Yes __No __

2. *The Big Event*. It could be a party, a vacation, a class reunion, a wedding, or going home to visit your family. You want to get into that special dress or bathing suit. This event will be the motivation that you have needed. This time you will succeed at losing the weight.

Yes __No __

3. *Relationships*. A woman in a *Diets Don't Work* seminar in Houston was very specific about why she wanted to lose weight. She explained: "I just got a divorce and I want to get back down to my *hunting weight!*" Maybe it's time for you to get out there and meet new people or rekindle your present relationship.

 Yes __ No __

4. *Habit*. Life is an endless weight-loss diet for you. You would not know what to do with yourself if you gave up the quest for thinness. You've always wanted to lose weight, and if you stopped dieting to lose weight, something would be missing. You don't even think about going on a weight-loss diet anymore — you do it as a matter of course.

 Yes __ No __

5. *To Get Attention*. When you go to lunch with friends, you can tell them you're trying to lose weight. They'll feel sorry for you and ask you all about it. "What kind of diet is it? How does it work?" If you didn't have this problem, you might have to spend the whole time with nothing interesting to talk about.

 Yes __ No __

6. *To Get a Job or a Promotion*. You're going to breeze into that office looking like a stick, and they will beg you to take the job or the new position.

 Yes __ No __

7. *Clothing*. The button that popped off last week was the first clue. Time to knock off a few pounds or you won't be able to get into your clothes. You'll have to buy a whole new wardrobe. Or maybe you want to buy new clothes, but refuse to spend any money on yourself until you lose all the weight.

 Yes __ No __

8. *It's Summer*. Uh-oh, bikinis. The beach or the pool with all those semi-naked bodies — including yours. Big sweaters and baggy slacks are out of place on the beach.

Yes __ No __

9. *Life Is Going To Be Wonderful*. You'll finally crossed the river into *Happyland*, where all the thin people live. Everything over there is just great. All is perfect.

Yes __ No __

10. *To Gain Self-confidence*. Look out! When you get thin, the world had better watch out. You'll be a dynamo. Nothing will be able to stop you. You'll be able to go anywhere and get exactly what you want.

Yes __ No __

11. *To Prove You Can*. Whether you're proving it to yourself or to other people, someone is going to know that you can do it. They don't believe you anymore. After all these years, it is beginning to be too much for your pride. You'll show them this time.

Yes __ No __

12. *To Win a Bet*. A way to get thin, motivate yourself, and make a little money at the same time!

Yes __ No __

13. *To Be Healthier*. No more worrying about the health problems overeating and those extra pounds might cause. You're going to be the perfect specimen of health. You'll live to be a hundred.

Yes __ No __

14. ***To Stop The Nagging***. Nag, nag, nag! Are you tired of that! Losing your weight would be worth it just to shut them up.

 Yes __No __

15. ***To Start Eating Again***. What do you fantasize about when you've lost all that weight? Eating again! When you're thin, you'll be able to eat just like normal people. No more restrictions!

 Yes __No __

16. ***To End The Misery***. Life isn't worth living if you're fat. Every day you feel worse about yourself. You hate the way you look.

 Yes __No __

17. ***The Doctor***. The doctor told you that you have to lose weight. You have another appointment scheduled, and you know you're going to have to get on the scale — again. You can already see the nurse's raised eyebrows.

 Yes __No __

18. ***That Special Person***. You've met Mister or Miss Wonderful. This is your big chance. If you blow it this time, there may never be another. If ever there was a time to lose weight, it's now.

 Yes __No __

19. ***To Improve Your Game***. Imagine how much better you are going to be at sports without those extra ten to thirty pounds. The extra weight really slows you down whenever you try to move your body.

 Yes __No __

20. ***To Look Younger***. People guess that you are ten years older than you actually are. The fat is making you look and feel old before your time.

 Yes __ No __

21. ***Popularity***. You don't have a lot of friends because you are overweight. People will really like you when you are thin.

 Yes __ No __

Exercises (3 minutes)

1. Make a list of any other reasons that have motivated you to lose weight in the past.

 a._____

 b._____

 c._____

 d._____

 e._____

2. These are the real (or imagined) obstacles I've faced in the past when I've tried to lose weight:

 a._____

 b._____

c._____

d._____

e._____

The reasons overweight people have for losing weight vary. Some are internal, some are external. Some reasons for losing weight are for you, some are for others in your life.

The reasons to lose weight all have one thing in common: *they aren't good enough*. If they were, you would have already lost weight and kept it off. They're good reasons, but they aren't good enough.

The Best Reasons For Not Losing Weight

Let's look at several reasons why you have *not* wanted to lose weight in the past.

1. *You're a Good Person, and You Don't Look That Bad*. You don't have to lose weight to prove anything. If they don't like the way you are, who needs them?

Yes ___ No ___

2. *To Prove Someone Wrong*. Your family or friends told you that all you have to do is follow the weight-loss diet and exercise to be thin. Losing weight is not that easy. You have a far more serious problem than anyone realizes, and you're going to show them how wrong they are!

Yes ___ No ___

3. *People Would Leave You*. They would be envious of the new you. You've made positive changes and they haven't. You'd rather keep the weight on than make them feel uncomfortable.

Yes __No __

4. ***The Weight Would Just Come Back***. It will be like all the other times. Each time you have lost your weight, you've never been able to keep it off. Why make yourself miserable trying? It's hopeless.

Yes __ No __

5. ***Money***. You would have to buy a whole new wardrobe. Everything you own would be hanging around your knees. At today's prices it'll cost a small fortune. You don't have the money to do that right now. Better wait until you pay off your credit cards and save up some money.

Yes __ No __

6. ***What Would You Do With Yourself?*** What would you talk about, worry about, read about, plan for? How would you occupy your time if weight and food were no longer the most important issues in your life?

Yes __ No __

7. ***Fat Is Safe***. What if everyone found you attractive even though you are married or going with somebody? You don't want to ruin your present relationship, do you? If you got thin, someone could make advances, or you might be tempted to become promiscuous!

Yes __ No __

8. ***No More Excuses***. If you lost the weight, you would have to confront relationships, success, and all those other things on your "after I lose weight" list. Now you can blame the fat for everything.

Yes __ No __

9. *Why Change?* Losing weight won't make any difference anyway. You're not walking around with rose-colored glasses. Being thin doesn't guarantee happiness. Why put yourself through the agony of dieting?

Yes __ No __

10. *Discipline Is Too Hard (and No Fun!)*. Weight-loss diets are a drag! You have enough problems without the limitations of dieting. Discipline is not exactly your strong suit. You always fail at anything you do that isn't fun.

Yes __ No __

11. *Feeling Strong and Powerful.* You spent your whole life eating so that you would grow up to be big and strong. Congratulations — you made it! If the weight were gone, they would run all over you. People don't mess with you now. You can throw your weight around, and people take notice.

Yes __ No __

12. *Health*. Losing and gaining weight again and again is really bad for you. Staying overweight is better than getting back on that weight-loss/weight-gain roller coaster.

Yes __ No __

13. *Fat: The Fall Guy*. It's another great reason to stay overweight. If someone doesn't like you or leaves you, it's not your fault. You can explain their rejection. They're leaving your fat — not you.

Yes __ No __

14. ***Bigger Problem.*** The weight problem is familiar. You know how to handle that problem — just keep complaining! If the weight were to disappear, bigger problems would show up. If you keep kicking the fat around, you get to keep the other problems waiting.

Yes __ No __

15. ***To Punish Someone.*** If someone wants you to lose weight even more than you do, they've handed you the perfect weapon. Any time they step out of line or make you unhappy, you can just head for the refrigerator.

Yes __ No __

16. ***You Hate Your Body.*** You don't like your body and you treat it as if you hate it. You know every detail about what is wrong with you. No matter what you have done, your body doesn't look the way you want it to. Why spend time or effort losing weight for someone you don't care about?

Yes __ No __

17. ***Being Vulnerable.*** The armor, the overeating, that protects you will be gone, revealing your most sensitive, tender feelings. Take the armor away and you will be vulnerable. No longer will you be able to avoid those feelings with food.

Yes __ No __

Exercises (15 minutes)

1. Make a list of any other reasons that may have prevented you from losing weight in the past.

a._____

b._____

c._____

d._____

e._____

2. In reading over my list for not losing weight, these are the main reasons I haven't lost weight in the past:

a._____

b._____

c._____

d._____

e._____

3. These are the fears or concerns that may be stopping me from losing weight:

a._____

b._____

c._____

d._____

e._____

4. This is what it might take for me to break through those reasons, fears, and concerns:

a._____

b._____

c._____

d._____

e._____

5. This is the very *first* step I would have to take:

6. This is the *next* step:

What do all these reasons for not losing weight have in common? They work! You are still overweight, aren't you?

Discouraging as it may seem, you've taken an important step forward — you're starting to recognize what works and what doesn't.

Does This Puzzle Have A Solution?

In brief summary, this is what we've discovered:

- Weight-loss diets don't work for losing weight or keeping it off for very long.
- Weight-loss diets are great for gaining weight, and you are living proof.
- The reasons overweight people eat are infinite in number, but few of those reasons have anything to do with physical hunger.
- All the reasons for eating, other than physical hunger, cause you to gain weight.
- None of your reasons for losing weight have worked.
- All of your reasons for not losing weight have worked well.
- If you do lose the weight and continue to do the same things that you did in the past, you'll gain the weight back.

Losing your excess weight looks really hopeless, doesn't it? If there seems to be no solution to the problem, it's because you've been headed in the wrong direction. With a Diet Mentality as your starting point, you could never reach *naturally thin*.

Until you finish reading *DIETS DON'T WORK*, allow yourself to become a dedicated research scientist. Be completely objective. Give up every notion you've ever had about losing weight.

We're about to examine how *naturally thin* people relate to food. The exciting part is that I have discovered a way for you to experience what it's like to be *naturally thin*. This unique experience of being *naturally thin* will give you a new perspective about losing weight and keeping it off.

Chapter

What "Naturally Thin" People Think and Do

The Secrets To Being "Naturally Thin"

Although the secrets to being *naturally thin* are simple, the transition can be tricky. During my 38 years of researching weight-loss, I made an important discovery — becoming a *naturally thin* person requires a 180-degree shift in your approach to food, eating, yourself, your body, and your life.

- Are you ready for the secrets?
- Do you what to know how *naturally thin* people stay thin without dieting?

Like most truths, once you see the answer, it is simple. *Naturally thin* people do four fundamental things when they eat that overweight people don't.

- A *naturally thin* person eats only when their body is *hungry*.
- A *naturally thin* person eats *exactly* what they want to eat.
- A *naturally thin* person *enjoys* every bite of food they put in their mouth.
- A *naturally thin* person *stops eating* when their body is no longer hungry.

The secrets of eating like a *naturally thin* person are that simple. I couldn't believe it at first and tried to complicate it — convinced that it was the food they ate, or when they ate it, or at least their metabolism.

I discovered that some *naturally thin* people eat junk food, and some eat health food. Some eat an early dinner, and some eat late. Some eat quickly, others eat slowly.

What *naturally thin* people have in common is that they eat when their bodies get *hungry*, they eat *exactly* the food their bodies want, they *enjoy* every bite — staying conscious of the effect it's having on their body's hunger, and they *stop eating* when they are no longer hungry. If you stop and think about it, that's how *children and animals* eat. It's the *natural* approach to eating.

Let's take those four natural basics — one at a time.

1. Naturally Thin People Eat Only When They Are Hungry. It doesn't occur to *naturally thin* people to combine donuts and sadness, as overweight people often do. Their days don't revolve around food. Sometimes you will even hear them say things like, "Oh!, I think I forgot to eat today."

The only time *you* forget to eat is when you're asleep or unconscious. If *naturally thin* people aren't hungry, they don't think about food. Eating isn't an issue in their lives since they have permission to eat exactly what they want whenever they get hungry.

It never occurs to *naturally thin* people to eat for any of the reasons that overweight people do. *Naturally thin* people eat because their bodies are hungry, and that's it! They don't waste food by eating more than their bodies need. Food is food. Food is never love, comfort, sex, companionship, etc.

2. Naturally Thin People Eat Exactly What They Want.
Naturally thin people do something overweight people never do. Before they sit down to a meal, they ask themselves what they want to eat. "Grazing" (see Chapter 4) is an unfamiliar concept to *naturally thin* people. They decide what food they want before they start eating.

3. Naturally Thin People Consciously Enjoy Every Bite.
Naturally thin people are conscious of what they're eating and the effect the food is having on their "body hunger." A *naturally thin* person would never find their hand at the bottom of the popcorn box wondering who ate the popcorn.

Naturally thin people consciously enjoy what they're eating. *Naturally thin* people are satisfied with less because they enjoy their food more.

Whenever I used to buy ice cream cones, the first bite would taste just great. After the second or third bite, I couldn't taste the flavor anymore — all I could taste was *cold*. If a *naturally thin* person stopped enjoying the ice cream, the rest of it might be thrown away!

A man named Melvin, from Houston, once told me that whenever he tried to get his son to finish the food on his plate, the child would say, "I'm tired of eating!" Overweight people never know when they get tired of eating because they do it so unconsciously.

Eating consciously is like driving a stick-shift car — it may be difficult to master at first, but once you learn, you never think about shifting again. First learning to eat like a *naturally thin* person requires effort. You need to pay attention to what you're eating. After a while, eating consciously and enjoying every bite becomes second nature — like using a stick-shift transmission.

4. Naturally Thin People Stop Eating When Their Bodies Are No Longer Hungry. Did you ever have someone try to press food on you, even when you said, "I'm on a diet!"? *Naturally thin* people have two magic words that stop those people dead in their tracks. They say, "I'm full." If pressed, they just keep repeating "I'm full," with more conviction.

I've seen *naturally thin* people stop eating right in the middle of an expensive meal without the slightest hesitation. I've seen them wrap up and save just a few bites of food, or take all but two sips of a soft drink — and put it back in the refrigerator. When you ask them why they don't finish it, they say, "I'm full. I'll have it later."

I discovered that "doggie bags" at restaurants were invented for *naturally thin* people. Why? Because overweight people eat everything on the table before they leave!

Naturally thin people don't care about being in The Clean Plate Club. On rare occasions they will overeat a little, but they never give it a second thought.

Naturally thin people don't give food much importance. They will ignore it, forget to eat it, and even throw perfectly good food away. *Naturally thin* people treat food as a servant, not as their master.

Most overweight people have no idea how hungry they are — before, during, or after eating. Eating consciously is how *naturally thin* people know when their bodies aren't hungry anymore. *Naturally thin* people are tuned in to their bodies. They *feel* when their bodies have had enough.

Naturally thin people basically only know four things: *when* they are hungry, *what* they want to eat, *what* each bite of food they put in their mouth tastes like, and *when* their bodies have had enough food.

For now, there's only one other secret that you need to know to begin the transformation of your Diet Mentality into a Naturally Thin Mentality. *Naturally thin people never go on weight-loss diets. Only overweight people diet!*

Exercises (6 minutes)

1. These are the reservations I have about eating *only* when my body is hungry:

———————————————————————

———————————————————————

———————————————————————

———————————————————————

———————————————————————

———————————————————————

———————————————————————

2. These are the reservations I have about eating *exactly* what I want:

3. These are the reservations I have about what might happen if I had to *consciously* enjoy every bite of food:

4. These are the reservations I have that I might not *stop* eating the moment my body is no longer hungry:

Who are these foolish people that don't even know the number of calories or fat grams in a chocolate chip cookie; who don't know *how* they stay thin?

Naturally thin people don't *know* how they do it. This is exactly the point. *Naturally thin* is a *natural* state. The Diet Mentality complicated everything. Going on a diet is *against* your body's nature.

The myths and rules promoted by the *thirty-billion*-dollar-a-year diet industry keeps overweight people caught up in the great American pastime — dieting.

Portrait of a "Naturally Thin" Eater

Here are some of the basic elements of being *naturally thin* I have discovered to make your transition to *naturally thin* easier:

- *Be Yourself.* The *naturally thin* are like animals in the wild, following their body's instincts from moment to moment. It's the weight-loss dieters that have gone against nature.

- *Reward Yourself.* It never occurs to *naturally thin* people to use food as a reward. *Naturally thin* people might reward themselves by taking the afternoon off to go to a movie or to go shopping to buy some new clothes. *Naturally thin* people don't use food to punish themselves or others.

- *No "Grazing" Allowed.* *Naturally thin* people don't "graze," because they always have something particular in mind when they eat. They don't indulge in scarcity eating. They know that food is always available.

- *Deprivation Prohibited.* *Naturally thin* people never diet, so how could they ever experience deprivation or scarcity. *Naturally thin* people have permission to eat exactly what they want — whenever they are hungry. So what's the hurry? If you ever have to face the choice between overeating, or feeling deprived — choose to overeat. In the long run, feeling deprived does more damage than overeating once in a while.

I know the above advice sounds outlandish, but eating those extra bites are not as important as letting go of your Diet Mentality. The few times you find yourself tempted to overeat can be an advantage.

Those episodes of eating when you are "not hungry" can teach you why *naturally thin* people don't overeat. I call this activity "overeating consciously" (enjoying every bite and thinking about nothing else except the pleasure you're getting out of each and every bite).

- *Listening*. *Naturally thin* people listen to what their bodies tell them to eat. I seldom found that *naturally thin* people were overly concerned about the nutritional value of food. They may eat three chocolate bars one day and not eat chocolate again for a month.

 Naturally thin people trust their bodies' instincts, even when those instincts may seem irrational. I know one *naturally thin* person who is usually a vegetarian. About every three months she gets an irresistible craving for two hamburgers, a large order of fries, and a chocolate shake. Nothing else will do. When she feels the urge coming on, she just shrugs her shoulders and says, "My body wants it."

- *Do What?* Sometimes a *naturally thin* person can't remember whether it's "starve a fever, feed a cold" or the other way around. No problem. The *naturally thin* person will just ask, "Does my sick body feel like eating or does it want rest?"

- *Hungry Feels Good*. Some *naturally thin* people get to the point where they actually enjoy the feeling of being a little hungry. *Nadine, from Aspen, after practicing being naturally thin for a while, said, "I feel so alive, like I could run a marathon. I feel awake. I have so much energy."*

- *Showtime!* *Naturally thin* people never indulge in closet eating. What do they have to hide? In fact, with food, they often do the opposite. *Naturally thin* people are more likely to eat when

someone's watching. They may eat more in a restaurant or with other people than they do when they're at home alone. It's a mystery to overweight people how a *naturally thin* person can sit down and devour an enormous meal. The answer is that tomorrow, when alone, they may not eat much at all.

- **When The Going Gets Tough...** When *naturally thin* people are anxious, they are more inclined to undereat than to overeat. They don't understand the habit of overeating to bury their emotions or problems under food. They may pace back and forth, sleep more than normal, make a list of the pros and cons of all of their options, go to a movie, or read. When they're upset or worried, food is the farthest thought from their minds.

- **Food Is Food.** To *naturally thin* people food is neutral. It's fuel to keep their bodies functioning. To them eating is like breathing — *natural and necessary. Naturally thin* people are often ignorant about food. They find the Diet Mentality's preoccupation with counting calories or fat grams baffling.

- **Do What's Best.** *Naturally thin* people eat the food they want, but they don't eat to try to get happy. They do things that are fun and that make them happy.

Are you beginning to get behind the naturally thin person's eyes and see their approach to eating and food?

- **The "Fountain Of Youth."** DIETS DON'T WORK is about more than just the four things that *naturally thin* people do when they eat. This book is about discovering where those four elements of *naturally thin* eating come from. It's about duplicating the Naturally Thin Mentality.

- **The "Naturally Thin" Diet.** Don't turn eating like a naturally thin person into another list of rules you won't follow. If you don't change your Diet Mentality, you won't be any better off than if you'd gone on another weight-loss diet.

- ***Think Naturally Thin.*** Begin to practice *thinking* like a *naturally thin* person, *feeling* like a *naturally thin* person, and *behaving* like a *naturally thin* person. At first you may have to pretend, but, for now, just "be" *naturally thin.*

- ***Live Naturally Thin.*** One of the first steps is to change your self-image. Begin to create an environment in which the *naturally thin* person inside of you feels secure and starts to emerge. Act *naturally thin* every chance you get. Get rid of the Diet Mentality and it's only a matter of time until your your body reflects who you really are. Until your new Naturally Thin Mentality becomes second nature.

Exercise (5 minutes)

Take a few minutes to begin to feel, think, and act like a *naturally thin* person. Start by reading *out loud* your responses to the exercise in ***Your Best Friend*** in Chapter 3. This will begin to give you ideas about how to start treating *yourself* like a *naturally thin* person. Your *naturally thin* person's imaginary best friend is *you.*

The exercise asked you to list:

1. Five *personal* things my imaginary best friend could do for me that would make me feel cared about.

2. Five things my imaginary best friend could do for me *at work* that would make me feel cared about.

3. Five things my imaginary best friend could do for me *around the house* that would make me feel cared about.

4. Five things my imaginary best friend could support me in doing for *my body* that would make me feel cared about.

Carol, who took the ***Diets Don't Work*** seminar in Los Angeles, wrote:

The first few days I couldn't believe how scary it was to live like a naturally thin person. There was almost too much freedom. Then I started exploring some of the things I could do with my new freedom — like doing things for myself that would make me feel cared about. I began to work on my "incompletions" list rather than stuffing myself with food.

I started out with the easy ones and worked up to those that would make me feel best about completing. I stopped criticizing myself on what I was not doing and began to focus on what I was accomplishing. It was great! I'm taking it step-by-step now and discovering a whole new world of naturally thin that I forgot had existed.

You didn't have to diet to *gain* the weight — you don't have to diet to *lose* it.

Just as you can't put a *naturally thin* body underneath a fat person's head, you can't keep that *fat person*'s body underneath a *naturally thin* head for long. If you *think and act* like a *naturally thin* person, your body will effortlessly follow suit. After a while, all you'll have to do is enjoy and *have fun being naturally thin.*

Exercises (5 minutes)

Take at least five minutes to do this exercise. When you finish, write down any comments you have about visualizing this experience.

1. Lean back, close your eyes, *let go of any stress you are holding in your body*, and visualize yourself as a *naturally thin* person.

- Take yourself through a typical day.
- Notice what the *naturally thin* you would do, how the *naturally thin* you would interact with people, and how the *naturally thin* you would eat.
- Create this *naturally thin* day exactly the way you want it.

2. These are the things that would be different about my life if I became a *naturally thin* person:

a._____

b._____

c._____

d._____

e._____

3. On a scale of 1 to 10, this is how I rate my chances of becoming a *naturally thin* person: (10 = absolutely certain; 5 = maybe; 1 = never.)

Answer _____ Today's date _____

In order to experience the Naturally Thin Mentality, there are several things you will need to know. For now, a brief introduction to *naturally thin* eating is all that is necessary.

Levels of Hunger

How does a *naturally thin* person know if he or she is hungry? Most overweight people have forgotten how to recognize physical hunger. They often look at their watches to see whether or not it's time to eat.

We were all born *naturally thin.* This idea is hard for some overweight people to believe, but have you ever tried to put food in a baby's mouth when he or she wasn't hungry?

What happened? They spit it out! How do babies know, even before they have learned to tell time, whether they are hungry or not?

They *feel* it! *It's a body sensation. Hunger is a feeling! Naturally thin* people are in tune with their bodies. They *feel* when their bodies have had enough.

What *does* "hungry" feel like? I've devised a *hunger scale* from Level 1 to Level 10 to help you identify your different levels of hunger. Start at a Level 1, the bottom of really hungry, and work your way up the levels of hunger. Can you remember a time when you hadn't eaten for a long time? Can you remember experiencing any of the following levels of hunger?

- *Level 1.* You're wobbly and dizzy. You can hardly think. The fuel gauge of your body is on *Empty*. There's absolutely nothing in there. You don't even care if what you eat is dead yet — you are going to eat now! Most people have to go without food for a long time to get close to *Level 1*.

- *Level 2.* You're still very hungry, but you could probably stagger to the dinner table. It's obvious to everyone that you're cranky and irritable.

- *Level 3.* You are "nice and hungry." Eating now is going to be very enjoyable.

- *Level 4.* You're only a little hungry. Your body could eat a little something, but it's slightly more trouble than it's worth.

- *Level 4.9.* Your hunger has almost totally disappeared. You may be just one bite away from "not hungry."

- *Level 5*. Your body is at "not hungry." It had what it needed and is satisfied. *Level 5*, "not hungry," is where *naturally thin* people stop eating. This is the level that *naturally thin* people call "full." We recommend that you use the phrase "not hungry" to describe this level. *Level 5* is not what an overweight person calls "full." (See *Level 6* below for clarification.)

If you continue to eat after Level 5 ("not hungry") you enter the levels of overeating.

- *Level 5.1*. You've put just a tiny bit more food into your body than it needs. You have crossed the line. Your body didn't need any more food, and all the food you eat from this point on is stored as fat.

- *Level 6*. You're beyond "not hungry." This is the level that overweight people call *full*. At this level you are becoming aware of a slightly bloated feeling in your stomach which has enlarged beyond normal "fist" size.

- *Level 7*. You're becoming uncomfortable. You are starting to feel as if your stomach has stretched a few inches. The bloat is making you feel a little stuffed.

- *Level 8*. You're more than "full." It's starting to hurt. You wish you hadn't had that second helping.

- *Level 9*. Your bloated stomach is frantically calling, *"Help me! Help me!"* The bloat is unmistakable. Eating is not fun anymore. The buttons on your pants feel like they are going to pop.

- *Level 10*. This is "Thanksgiving Day" full. You collapse on the couch, unable to move any further. You're starting to feel as if you might have to be lifted onto a truck and hauled away. You didn't realize you were eating that much. Now, you are really sorry. Your stomach hurts for hours and you swear you're not going to eat again for a couple of days.

Exercises (5 minutes)

1. Use the instructions below to find out what your level of hunger is right now.

 a. Close your eyes. Relax and place your hands on your stomach.

 b. Ask your body if it's hungry. If you're hungry, your level of hunger is between 1 and 4. Maybe you're not hungry at all, and it's a Level 5.

 c. Sometimes you may think you are definitely hungry, but if you don't drink enough water, check again. Overweight people often misinterpret hunger for thirst. The sensations of hunger and thirst are similar. This problem is easy to correct. Just take a few sips of water. If your "hunger" goes away, you were thirsty, not hungry.

 d. Listen to what your body says. Your *naturally thin* body will give you a lot of information if you listen to it.

Write down your hunger level: _____

You may not have listened to your *naturally thin* body for quite a while. Your body may be a little unresponsive when you begin. Keep listening. The more you listen to your *naturally thin* body, the more it will have to say.

Figuring out your level of hunger takes a little time and practice. Remember, if your hunger level is under Level 5, you're feeding your *naturally thin* body. If it's over Level 5, you're feeding your head. The problem is that it's your body, not your head, that gets fat.

2. Approximate your level of hunger when you last ate:

Breakfast _____ Lunch _____ Dinner _____

3. Approximate your level of hunger when you stopped eating:

Breakfast _____ Lunch _____ Dinner _____

Each Day In the Life of a Naturally Thin Person

Naturally thin people approach food and eating differently than overweight people. Just a few pages back, you were introduced to the four things *naturally thin* people always do that overweight people never do. They are so important, and so simple, they bear repeating.

Naturally thin people eat only when they are *hungry*.

Naturally thin people eat *exactly* what they want to eat.

Naturally thin people consciously *enjoy* every bite of food they put in their mouths.

Naturally thin people *stop eating* when their body is no longer hungry.

Naturally thin people do all of these things without conscious effort. If you are to begin to think and live like a *naturally thin* person, you will have to re-think your approach to food and eating. The following steps are designed to help you experience eating your meals as if you were already *naturally thin*.

If you come away from this *DIETS DON'T WORK* experience with nothing else but an increased awareness of thinking and eating like a *naturally thin* person, you will have taken a giant step toward enjoying life as a *naturally thin* person.

1. Size Up Your Stomach

Take your right hand and make a fist with it. This is the approximate size of your stomach when it has shrunk down to normal size. Even if you're completely empty, you may find that the volume of food you need to eat to satisfy your body's hunger will only fill a container not much larger than the size of your fist.

2. Rate Your Hunger

To be *naturally thin* you'll need to be clear about when you're hungry and when you're not.

Remember, Level 1 is when you're so hungry you're starving. Level 10 is when you're so stuffed you can't move. Exactly in the middle, Level 5, is the point at which your body has had just

enough to eat. Everything up to Level 4.99 is "hungry." Everything from Level 5.01 on up is "overeating" or "too much."

When you begin to work with the hunger scale, you may feel awkward. You probably haven't experienced hunger feelings in a long time. At first, you may confuse the body sensations caused by fatigue, loneliness, thirst, excitement, or nervousness with being hungry.

3. Rate Your Food

I want you to learn how to rate food. *Naturally thin* people generally only eat foods they really love.

I've developed a food-rating scale for you, using the numbers from 1 to 10. The smaller numbers on the bottom of the scale represent your *least* favorite foods. The larger numbers at the top of the scale represent your *most* favorite foods. Foods at the low levels of 1 or 2 have no business being in your mouth.

Naturally thin people generally only eat foods that they rate 8, 9, or 10. The food-rating scale is entirely a matter of taste — everybody has different preferences.

 10 **Wonderful, Orgasmic**
 9
 8 **Pretty Good**
 7
 6 **Okay, but not quality**
 5
 4 **Not Good**
 3
 2 **Ugh!**
 1

4. Disconnect The Eating Machine

In order to follow the third basic principle of *naturally thin* eating, that is, eating and enjoying every bite consciously, you have to learn to take yourself off *automatic*. You have to "disconnect" the eating machine. The object is to keep your attention on the food that's already in your mouth, so that you enjoy and taste each bite.

Practice disconnecting the eating machine by 1) Putting your fork down before starting to chew, and 2) Slowly, consciously and completely chewing each bite of food and swallowing it before picking up the fork again.

When you begin to disconnect the eating machine, you will discover for yourself that you have not been tasting or enjoying your food as much as possible.

5. Enjoy Each Bite Consciously

Naturally thin people consciously enjoy every bite of food they put into their mouths. At all times while you are eating like a *naturally thin* person, put each bite of food into your mouth and disconnect the eating machine. *Before* you begin to chew, put your fork down on the plate. Chew each bite very slowly. Savor every drop of the flavor until nothing is left. Mentally rate each bite on a scale of 1 to 10. Then, if you are still hungry, select your next favorite bite on the plate. Enjoy it thoroughly, as above.

6. Do What Naturally Thin People Do When They Are Not Eating

On each *naturally thin* day, keep your list of incompletions and goals from Chapter 3 handy. Pick out five or six incompletions from your list that you would like to complete each day. You may not come close to completing that number, however, the number of completions is not the object. The purpose is for you to do what *naturally thin* people do, rather than concentrating on food or losing weight.

7. At the end of the Day

At the end of each naturally thin day, congratulate yourself for letting your *naturally thin* person be in control. Each night before going to sleep, take a few minutes to write down your positive impressions of what eating and living like a *naturally thin* person was like for you. Use the following space and the blank pages in the front and back of the book.

 In the next two chapters, I'll be discussing making the choice between the *Diet Mentality* and the *Naturally Thin Mentality*. Now that you've had an opportunity to experience what it is like to be *naturally thin*, you'll be more informed about your choices. You might choose the *fat person* over the *naturally thin* person. The choice is not as clear-cut as it may at first appear.

Chapter

7

The Temptation To Choose "Fat" Over "Naturally Thin"

Most people with a weight problem have never had the opportunity to choose whether to be *naturally thin* or not. So much emphasis is placed on being thin that it seems to go without saying that every overweight person *should* want nothing else. Thin is good and overweight is bad. This is where the Diet Mentality does most of its damage, with the idea that nothing else in life is as important as being thin.

People do everything they do for good reasons. People have weight problems for good reasons — somehow not losing weight works better for them than doing what it takes to be thin.

In this chapter we're going to look at why some very intelligent people might prefer to stay the way they are, rather than become *naturally thin*. If you're uncomfortable with what you discover in the following sections, please don't beat yourself up. We're preparing you to make a choice. In order for it to be an intelligent choice, you need to know as much as you can about being or staying overweight.

The sections in this chapter are designed to show you how overeating and being overweight are tied to important aspects of your life. As you've already seen, the Diet Mentality isn't the intelligent way to lose weight and keep it off. However, it has payoffs that can be very reasonable and attractive. Following are some of the major elements of the Diet Mentality.

Bake Someone Happy

Food is at the very heart of why you might want to choose overeating and being overweight over *naturally thin*. Food is woven into most of our relationships with other people.

People use food to tell us that they love us. Sometimes they can't find the words to say it, so they bake us a cake. Other times they use food to get us to spend time with them. Food is put out on the table to make everyone sit down and talk to each other. Parents offer us food to show they love us. We, in turn, eat the food to show that we love them.

Janet, from Houston, wrote:

I started getting fat when I was about thirteen years old. At that time my mother (who had been divorced for several years) was out of work and my older sisters were supporting our family. I imagined that my mother felt helpless and useless and needed to do something that would make her feel good about herself.

We began a sort of ritual that year. When I would come home from school, she would already have dinner ready and would encourage me to eat. Then my sisters would come home from work, and she would again encourage me to eat.

Somehow I could sense how important it was to her, so I began eating two dinners every night. I wasn't her favorite child, so I was always looking for ways to get her approval. Since I could always count on her approval for eating, even for overeating, I ate the two dinners and got fat.

Eating was not what I wanted, but what mother wanted. To do what I wanted, would have risked her disapproval, and I would have felt disloyal to her. Both feelings seemed dreadful to me at the time.

I realize now that I was playing a losing game with her. I wasn't doing what I wanted to do, so I wasn't satisfied. Of course, I really couldn't fulfill her need to feel useful. She still felt awful about being out of work.

My mother eventually got a job and we quit the two-dinner-per-night ritual, but by that time I was already fat.

I understand now that the game we played came out of our struggle to love and be loved by one another. Knowing that makes it possible for me to forgive both myself and my mother, and get on with my life.

Exercise (2 minutes)

These are all the reasons I might have eaten in order to win my parents' love or approval:

a._____

b._____

c._____

d._____

e._____

It's easy to get mixed messages from parents. They want you to be attractive. They encourage you to diet if you are overweight, but then they keep the refrigerator full of delicious food. They say they support you in losing weight, but sometimes act contrary to your expectations when you do.

A woman in one of my *Diets Don't Work* seminars told me that she and her mother were both overweight and were always talking about diets and encouraging one another. It seemed to be the one thing they had in common. But when this woman started to lose weight and her mother didn't, they stopped speaking to each another.

Parents are sometimes very difficult to win over. Because they love us, they want us to be as good as we can be. As soon as we start approaching the goals they set for us, whether in our work, sports, grades, or weight, they raise the standards. It seems we can never be good enough.

Trying to get thin to please your parents is fighting an uphill battle. They always want more from you. Your accomplishments are never appreciated or acknowledged enough.

Always raising our standards and then beating ourselves up because we fail to live up to those standards, is one of the tricks we learned from our parents. Most of our parents believed a good spanking when deserved would make us better, but it didn't — it just made us sneakier. The same thing happens when we beat ourselves up about our weight.

In a personal consulting session with me in Houston, Mary shared that when she thinks about her parents, she can actually taste certain foods in her mouth: *With my mother, I can taste apple pie when I think about her, and I feel all warm and cozy inside. With my father, it's cabbage. He always used to make me finish my cabbage before I left the table.*

Food was so much a part of her relationship with her parents that she could actually *taste* her parent memories.

Exercises (8 minutes)

1. These are the foods I remember when I think about my parents:

a._____

b._____

c._____

d._____

e._____

2. These are the things I can remember my parents talking about at the dinner table:

a._____

b._____

c._____

d._____

e._____

3. These are the general attitudes my parents probably gave me about my weight:

a._____

b._____

c._____

d._____

e._____

4. These are the circumstances in which my parents overate: (Any eating over a Level 5 [no actual physical hunger] is considered overeating.)

a._____

b._____

c._____

d._____

e._____

5. These are the circumstances in which I find myself overeating: (Any eating over a Level 5 [no actual physical hunger] is considered overeating.)

a._____

b._____

c._____

d._____

e._____

6. These are the subtle messages I got from my parents or relatives about food:

a._____

b._____

c._____

d._____

e._____

About Parents and Fat

When I was about seven years old, my father came home from serving in the Navy during World War II. He was six feet tall, very strong and muscular. I was a skinny kid, and I wanted more than anything to look like my father.

I tried everything to put on weight. I saved my money until I had enough to buy a bottle of a drug-store, weight-gaining elixir called *Wate-On*. I used it, lifted weights, and gained five pounds. As soon as the bottle ran out, and before I could save the money to buy another bottle, I lost the five pounds.

Everyone said, "Don't worry. You'll grow up to look just like your dad." I didn't want to wait. My whole life was about being like him.

When I was sixteen, puberty hit me with full force. I joined a health club and began lifting weights every day. In three months I had grown six inches and gained forty-five pounds. I was in heaven.

Fourteen years later I looked just as my father had looked when he got back from the Navy. I'd done what I wanted to do and never thought about it again until I was thirty-five. Then one day I looked in the mirror, and saw my head on my father's body — not the body he had when he came home from the war, but the body he had when he was thirty-five.

For all those years, my mind had been snapping pictures of him as he grew older, and I'd continued to pattern my body after his. I even took to drinking beer as he did, and now I had his beer-belly to show for it.

As I looked in the mirror, I realized that even though I still loved my father, I didn't have to have the same body he had. I had my own life to live, and I wanted my own body. At first I felt a terrible sadness. Then I realized I could love him without spending the rest of my life duplicating his body.

I started to visualize the body I would want if there were no one else on the earth — even if there were no one to compare myself with or impress. The image grew clearer and clearer to me, and that's the body I decided to have.

None of what happened was my father's fault, but it had a tremendous impact on my life. We often let our parents influence us without them even knowing it.

Exercises (15 minutes)

1. These are the general attitudes about my weight and my body that I got from my parents or family:

a._____

b._____

c._____

d._____

e._____

2. Get comfortable, close your eyes, and spend the next five minutes visualizing the body you would create for yourself if there were no one else on earth. Describe it in detail below.

3. At this time, can you trust yourself to make creating that *naturally thin* body a priority in your life?

 Yes __ No __

People tell all kinds of stories about their relationships with parents, family, and food. Sometimes an idle comment can set up a lifetime of beliefs.

Millie, who lives in New York, told about the time one of her father's friends came over to visit. Her father welcomed him and asked if he'd like something to eat. The friend said he wasn't hungry, and her father replied, "You have to be hungry to eat?"

4. These are the phrases relating to food and eating that I remember from childhood:

a._____

b._____

c._____

d._____

Denise, who took the same seminar as Millie, said that she was *naturally thin* until she was in her mid-teens:

When I was about fourteen, I noticed that my older sister, who was overweight, was getting lots of attention. She had to have special clothes, better clothes, to make her look good even though she was fat. I also wanted beautiful clothes and attention, and it wasn't long before I started putting on weight. I never realized until today that I don't have to do that anymore.

5.You can learn habits and beliefs very early in life. Did your mother or father use food to get you to sit down and be with them? Recall what it was like at the family dinner table. What feelings or thoughts can you remember having?

6.Were you ever rewarded or did you get positive acknowledgment for eating a lot? Describe your recollections.

7. Food can be a great barrier. You can put it between you and other people to avoid any real contact. If you're both eating, it's easy for your attention to be on the food instead of on one another. Did you or your family eat to keep from talking about problems? Describe any specific memories.

Struggling with weight or overeating can affect any relationship. Sometimes you may get a subtle message from people who are supposedly helping you lose weight. The message is that you are not OK with them the way you are.

If you are receiving that "You're not OK with me" message, consciously or unconsciously, you will feel some resentment.

You'll get even with them somehow — by not losing weight, continuing to overeat, or in some other way.

Another game you can play with anyone close to you is called "Even if I lose weight and give up overeating, you'll never give me enough praise or appreciate me enough."

People aren't mind-readers. They don't know how you want them to acknowledge you and your accomplishments unless you tell them.

Sometimes we don't *tell* people what we want because we're afraid they'll think we're selfish. Regardless of what they think, at least you've given them valuable information.

A man named Sam, who attended one of our Portland seminars, told us:

Every year when I went home for Christmas, my mother would have the refrigerator and the freezer stuffed with food I loved. If I ever said I liked anything, I could count on it being there when I got home. I always left weighing ten pounds more than before my visit.

One year I called my mother before my Christmas visit and told her I didn't want to gain the weight again this year. I explained that I loved her and her food, but eating the way I usually did when I was home made me unhappy in the long run.

She understood and cooked sensible meals for me from then on. I got the food I wanted, and my mother got to support me, which was really what she wanted to do.

Sometimes you will ask for something and not get it. That's fine. If someone doesn't want to give you exactly what you want, that's their choice. It isn't smart to try to get someone to do something that they really don't want to do. You'll wind up spending more energy than it is worth.

Exercises (5 minutes)

1. In the area of eating like a *naturally thin person*, what specific things do you want in the way of support from your friends, family, and associates?

a._____

b._____

c._____

d._____

e._____

2. Who do you need to tell about what you want?

a._____

b._____

c._____

d._____

e._____

3. When are you going to tell them?

By_____(fill in the date) I will have told every-
one I need to tell, exactly what I want from them in the way of
supporting me in being a *naturally thin* person.

Fat and Sex

I'm always amazed at the number of times this subject came
up in my *Diets Don't Work* seminars. We start out talking
about weight, and usually by the middle of the afternoon we're
talking about sex. It's almost impossible to talk about weight, it
seems, without also talking about sex and relationships. There is
a link between the two.

Many people aren't excited about losing weight because they don't want to confront the whole issue of sex and relationships. They have figured out that weight is a foolproof method of avoiding relationships without wearing a sign that says, "Don't come near me." Some have been hurt so badly they will do anything to avoid becoming involved again. If you got mugged every time you wore something red, how long would you continue to wear red?

Most overweight people have it in their minds that if they get thin, a sexual relationship would automatically follow. That's part of the *fantasy of being thin*, but it's not the reality. Thin people will tell you that being thin does not guarantee having the kind of relationship you really want.

Sometimes, people who want to avoid relationships haven't ever been burned. For some reason, they just don't want to get involved with another person or with sex. Maybe they don't know exactly what that reason is, but they do know they don't want to get involved in the sexual arena. They figure the best way to do that is to keep themselves from losing weight or becoming attractive. (They don't always succeed in being unattractive, by the way, even if they are overweight. There are some people who think fat is sexy. They like their mates to have soft, round, cuddly, romantic bodies. In some cultures, this body shape is a sign of beauty.)

Even if someone is attracted to them despite their weight, they can always fall back on the old Groucho Marx saying, "I would never join a club that would have *me* as a member." Or they might think, "If the guy is attracted to someone as fat and unattractive as I am, there *must* be something wrong with him."

Another way people connect sex and weight is through their lover or spouse. If they were to become thin and were attractive to other people, it might be threatening to their spouse. He or she would turn all *squirrely* on them.

Even worse, if other relationships were available to them, they might be tempted by the opportunity. They don't really trust themselves. Who knows what would happen if they suddenly became attractive and accidentally wandered into the sexual marketplace?

As long as you're overweight, you don't have to deal with the sex and relationship problem at all. You can maintain the status quo because no one is going to be attracted to you anyway. *If you don't really have a choice, you can't make the wrong decision,* and ruin your present relationship.

For some, the struggle with weight has become an integral part of their intimate relationships. Often a spouse wants them to lose weight, and is always offering advice about how to do it. They are badgered to go on another weight-loss diet. In the guise of "support" they are teased, manipulated, and punished for their shortcoming. It's a daily *grind*.

Overweight people cannot possibly enjoy such terrible treatment. However, the weight issue takes up such a large part of their relationship that they wonder how they would fill the void if it were gone. If they didn't have the issue of weight to talk and argue about, what would they say to each other? How else would they relate?

Sometimes a spouse inadvertently becomes a party to the Diet Mentality. For example, a husband, whether he verbalizes it or not, gets the message to his wife that if the weight doesn't go away, he will. He may even hold that threat over his wife's head and use it to manipulate her. If she can't lose weight, he implores, she can at least do a better job cooking his meals, or cleaning the house. He winds up getting her to do other things that she doesn't really want to do, or that don't make her happy in order to make up for her being fat.

Just try to lose weight with that hanging over your head. It's human nature to resist anything you *have* to do but haven't chosen for yourself. The resistance might not be conscious, but it's there. It's like being a kid again. It makes you feel powerless. You are once again having to do what others tell you to do.

You usually wind up fighting them to the death, even if "they" are your employer or spouse. It doesn't even matter if you also want the results that would be produced by doing what they are asking.

Most people don't mean to be unsupportive. Even some doctors have been taught that the way to help overweight people

lose weight is to give them a hard time about being fat. They're not necessarily trying to make you feel terrible; they just want to help and really don't know how.

In this section I've been talking about the woman who's fat, but it can just as easily be the other way around. It can be the man who's overweight, and the woman who's trying to get him to go on a weight-loss diet. In either case, some part of the relationship turns into a battle of manipulation.

In most cases neither party is clear about what they want. The spouse may want you to lose weight, but may really be afraid that the "svelte, new you" may become more attractive to the opposite sex.

You may say you really want to lose weight, but at the same time are unconsciously afraid of what you'll do with your new freedom. You might not want to lose the leverage you have by your ability to gain or lose weight. After all, now you can punish and drive your spouse crazy by gaining weight or reward them by losing it. *You* have all the cards.

An often-heard battle cry is, "I don't want to be loved only for my body!" By getting fat you can test the other person's love for you.

Some women are afraid that if they lose weight, their breasts will get smaller or they'll sag. These are realistic fears, especially if they are not doing toning and firming exercises as they are losing weight.

It isn't that unusual for people to describe their perfect weight as their *hunting weight*. If they were that size, they say, they would be out there on the prowl. Then God knows what would happen — they might be besieged with offers and would have to make some choices. Members of the opposite sex might be pawing their body. There would be no rest.

Sometimes this sounds great, but at other times it just sounds like a new set of scary problems. Our old familiar patterns are usually a lot more comfortable, especially if we've ever gotten hurt or rejected while we were out there hunting.

Exercises (5 minutes)

1. These are the ways being overweight may be influencing how I approach sex and relationships:

a._____

b._____

c._____

d._____

e._____

2. These are some of the payoffs I may be getting for having my weight be an obstacle in a sexual relationship:

a._____

b._____

c._____

d._____

e._____

Fat And Power

Often it seems that being overweight isn't about fat at all, but about power. Strange as it may seem, you do wield a lot of control over others by being fat. Some people may worry about you. They cajole you. They want to help you. They give you attention, even if it means getting angry with you and tormenting you.

Attention is something that most people want and need very badly. Have you ever noticed how children use their behavior to get attention? Children catch on fast to this idea. Any time you give them attention for doing something, they'll tend to do it again. If you give them more attention for making trouble than for cleaning up their room, they're more likely to make trouble.

Even punishment is a form of attention. If a child gets negative attention for being bad, they'll be bad. If they get enough positive attention for being good, they'll be good.

If you get more attention for being fat and overeating than you do for being thin, the chances are you will continue to overeat and be fat. This holds true whether the attention is from yourself or from others. If you give yourself a lot of attention for your fat, if you're always thinking and worrying about your weight, then you're getting a payoff for being fat.

If you're engaged in a struggle with someone over your weight or your eating, you're getting attention and have the power to manipulate that person. You can make them happy or miserable just by whether you eat too much or not.

You can bind people to you by being fat. Maybe you're their "good-deed" project — they won't rest until you're thin. They may love you and worry about you more because you have this weight or overeating problem.

Maybe many of your friends are also overweight, and your mutual struggle with food binds you together. If you stopped overeating and got *naturally thin*, they might go away. And well they might, if that's what your friendship is based on. If the bond is deeper, they'll still be your friends.

Another way some people connect weight and power is by actual size. Again and again I have heard in my **Diets Don't Work** seminars, "If I lost weight, I might feel like I would just blow away in the wind. I would feel so fragile and vulnerable. I don't like the way I look now, but at least people don't mess with me."

Over the years people start to think that the presence they project to the world relates only to their physical size. Somehow their weight protects them. No one is going to take on someone that big. They can't be ignored or taken lightly. If they were thin, they might get pushed around, or even worse, no one would notice them.

Other people relate fat and power in just the opposite way. They're afraid of the power they think will come to them if they get thin. If they were thin, they wouldn't have any excuse for feeling powerless. They might have to get out there and become everything they've always dreamed about being — sexy, powerful, and successful. The truth is, deep down they're afraid they might not succeed.

What if something incredible happened and overnight you became the person you've always wanted to be? It did not happen gradually — you were there now! Part of you would be excited, but another part of you would be scared to face such an immense challenge so suddenly. Perhaps too much would be expected of you, not only by other people, but also by yourself. Better leave things the way they are. Just go back to bed and have another cookie.

Some people have the idea that if they lost weight and gave up overeating, they would also lose control of their lives. Things aren't so great now, but they already have a tried and tested method of dealing with stress, discomfort, and anxiety — just eat!

What if they gave up overeating? What if they had no other way to regulate their emotions than the way they now do with food? It would be like setting them adrift in a small boat in the middle of the ocean — they wouldn't know where to turn or what to do. Now at least they have something that they know works. It might not get them what they want, but at least it's familiar.

Exercises (5 minutes)

1. These are the ways I might be getting more positive or negative attention by overeating and being fat:

a._____

b._____

c._____

d._____

e._____

2. These are some of the ways I get attention, both positive and negative, from myself for overeating and being fat:

a._____

b._____

c._____

d._____

e._____

Thank you for doing these exercises. Just a little more now and you'll be through one of the more uncomfortable sections in DIETS DON'T WORK.

Fat and Success

There are subtle differences between the ways people relate fat to power and the ways they relate fat to success. Relating fat and power usually has to do with your relationships with other people. Relating fat and success, more often than not, has to do with your relationship with yourself.

Most people think that they would be more successful if they were thin. Whether they define success in terms of career, family, relationships, spirituality, or the way they feel about

themselves, it's really all the same. *Thin equals successful.* As long as they have the fat they will allow themselves to only be partially successful. They're sure they would be even more successful if they were thin.

The fear of success is by no means unique to people who are overweight. Thin people just use other means to keep themselves from being wholly successful. Why are we afraid of success? There are many reasons, even some good ones. It's a complicated issue, and much has been written about it. Here we'll only deal with how the fear of success can prevent you from losing weight.

Some people fear success because they think if they had everything they wanted, their lives would be over. What would you do once you had everything? You would have nothing to occupy your time, no more problems to solve, nothing to care about. What would you do with all the energy you've used to get where you are? What would be the point in living?

Let me tell you a secret: *you can always come up with a new problem.* It's human nature to create problems and solve them; we do it instinctively. That's how we learn and grow. If you talk to a person who is fabulously rich, fabulously thin, and fabulously happy, you'll discover that there's always some new problem that he or she is working on. That level of success brings its own problems.

Also, every solution can be counted on to generate a new problem. There's always going to be some new challenge to face, something exciting on the horizon.

Another thing people fear about success is that they won't be invisible anymore. Maybe you think others will be watching you. Everyone will know if you have a relationship that doesn't turn out perfectly, or if you sneak into Baskin-Robbins for a mini-binge. Your life will be in the spotlight, and you'll never again be able to commit those secret little indiscretions

People may become jealous of you. If you've ever been envious of someone who's successful, then you can't help thinking that people are going to feel the same way toward you. You know all the back-biting and fault-finding that goes on. You might find

yourself rejected and alone, and that's not what you want. In addition, you don't know what you would be like if you were successful. Maybe you would become nasty and overbearing.

Maybe success wouldn't look so good on you. At least now your situation is familiar — you know who you are. To become a completely new person is frightening.

Some people play a different game. They want to prove that they can be successful despite their fat. According to a recent study, ten pounds can make the difference between getting or not getting a job — between getting or not getting a promotion. These people want to show the world that they can make it anyway. They can't seem to prove often enough that their weight has no affect on their worth, value, and abilities. They would rather be *right* than thin.

Exercises (10 minutes)

1. These are all the ways I might use being overweight and my overeating to keep from being completely successful:

a._____

b._____

c._____

d._____

e._____

f._____

2. These are the new problems I would gladly exchange for my old problems of overeating and being overweight:

a._____

b._____

c._____

d._____

e._____

f._____

3. These are some of the reasons I fear becoming more visible:

a._____

b._____

c._____

d._____

e._____

f._____

4 This is how being overweight and overeating is influencing my relationships with:

a. Sex

b. Power

c. Success

5. I think the main reasons I'm overweight are:

a._____

b._____

c._____

d._____

6. These are a few more reasons I have for overeating:

a._____

b._____

c._____

d._____

There may be times when you prefer the payoffs of overeating and being fat to the benefits of being *naturally thin*. If you do, that's really OK — *you* get to choose. Recognize that in the process you might lose the joy that the *naturally thin* person inside of you could be bringing to your life.

The Person in the Mirror

Another reason you might chose being fat and overeating over being *naturally thin* is that you would have to change your self-image. That may seem hard, even impossible. For a long time you've probably thought of yourself as a certain kind of person. Now if you want to be *naturally thin*, you're going to have to let go of that image and create another.

The old person, that *fat person* inside you, isn't going to like that. You'd better be prepared for some resistance. In a way it's a kind of death. There may be the same kind of sadness that I experienced when I let go of my father.

You don't particularly like the old friend you see in the mirror. Old friendships die hard, however, even those that aren't supporting you any longer.

The first thing you need to do is recognize and focus on just the positive things about yourself. Focus on the new person, the *naturally thin* person, who is emerging as a replacement. That person is probably a lot happier and closer to who you really are. That new, *naturally thin* person is going to carry you to a whole new level of living.

Imagine you're trading in an old, beaten-up station wagon for a spiffy little sports car. If you've had the station wagon for a long time, you may experience some sadness in giving it up. In the end, since you want the sports car, you just have to say good-bye to the station wagon. Thank it for all the pleasure it has given you, and focus on enjoying your new *sports car*.

But, What If...?

It's easy to convince people to adopt the first, third, and fourth guidelines of eating like a *naturally thin* person: eating only when they're hungry, stopping when their bodies have stopped being hungry, and consciously enjoying every bite of food. The guideline that's frightening to them is the second guideline, eating *exactly* what your body wants to eat.

Most people are afraid they'll gain pounds by the score during the first few weeks. The thought of letting yourself go and giving yourself permission to eat exactly what you want is terrifying. It goes against everything in the Diet Mentality.

You may assume that you'll want to eat nothing but Twinkees, cupcakes, lasagna, and cream pies. You see, anything you think you can't have takes on an aura of forbiddenness and desirability. You believe you're going to want it all the time. If you give yourself permission to have it whenever you get hungry, that insatiable desire fades away.

Giving yourself that permission eliminates what I call *Last Supper* eating. How many times have you looked down at some forbidden food, like a bag of brownies, and thought they would be your last? Or *should* be your last?

Those brownies become very special to you. You're a condemned person, and this is your last meal. Brownies become the most fascinating and succulent of foods. So when you fantasize about food, brownies are bound to be in the picture. If you could have a brownie anytime you were hungry and you wanted one, what would be the big deal?

A week after a **Diets Don't Work** seminar in Los Angeles, a participant named Ellen told us:

The strange thing was that I'd always thought if I could really eat anything I wanted, I would pig out on candy and shakes. After eating like a naturally thin person for the day of the seminar, I tried eating all of the candy and shakes that I wanted. Something was different now. They didn't taste the way I thought they should.

Your body is not dumb. It has instincts for self-preservation. It also has instincts for health and happiness. All the rules and deprivations you've been using only get in the way of those instincts.

Noreen, who lives in Aspen, said:

The first day I let myself have five Milky Ways! My mother never let me eat them when I was a child, and I guess I had always thought of them as forbidden fruit. It was funny, because the next day I went grocery shopping. When I got to the candy section and my eyes fell on those Milky Ways, I couldn't stand the sight of them. My naturally thin body was starting to assert a life of its own. The food it wanted that day was fresh, crunchy vegetables and fruits, so off I went to the produce section.

When you're riding a horse up and down a steep trail, sometimes it's best just to give the horse its head. You let him pick the path, rather than trying to tell him where to go. The horse's instincts are sometimes better than yours, and so are your body's.

You don't have to force your body to eat things it doesn't want. You may buy a whole refrigerator full of carrots and celery but your body may peek inside and say, "Yuk! I want a hamburger." That may be because it needs a hamburger.

How many times have you bought a refrigerator full of "thin food" and watched it rot? There's a whole generation of people who think that diet cottage cheese is something you bring home from the store, put in the refrigerator, let spoil, and then throw away. They may even think it's a necessary ritual if one is trying to lose weight. Like some kind of sacrifice to the *Thin God.*

Your body really is smart.

Christine, who lives in San Francisco, said that for a week after her naturally thin day she found herself craving raisins and parsley. She didn't understand why, but she could not get enough of either of them. "What an odd combination," she thought. Then someone told her that they were both high in iron. Her body was screaming at her to give it iron, and its message manifested in what she was craving.

When you get used to eating like this, your body starts to send you messages. It can often tell you very accurately what it wants and what it needs. It doesn't have any axes to grind other than its own well-being. It doesn't have any of the attitudes and patterns and points of view that you do. It only knows what it wants and what is going to make it feel good and be healthy.

Unless you have some disease or allergy that would stop you, try it. Let your *naturally thin* body speak to you. Trust that your body is on your side and has your best interests at heart.

Exercises (6 minutes)

1. These are my worst fears about what would happen if I gave myself permission to eat whatever my body wanted whenever I was hungry:

a._____

b._____

c._____

d._____

e._____

2. These are the best things that could happen if I gave myself permission to eat whatever I wanted when my body was hungry:

a._____

b._____

c._____

d._____

e._____

3. I can trust my *naturally thin* body's instincts because:

a._____

b._____

c._____

d._____

e._____

The "Fat Person's" Tactics

The two persons inside you, the *fat person* and the *naturally thin person*, are at odds. They operate in different ways, and they want different things. They have different goals. The same world isn't going to work for both of them.

It is important to recognize that the fat person has the edge right now. He's bigger, stronger, more clever, and more devious. He's been getting all the attention. You've been feeding him while you starved the *naturally thin* person.

He may try to fool you into thinking he's on your side. He may have been sitting on your shoulder while you've been reading this book, solemnly nodding his head, agreeing with everything that's been said. He laughs along with you as a truth sometimes hits you in the face like a whipped cream pie.

That *fat person* has a lot of influence over your behavior right now. When you start to replace him with the *naturally thin person*, you can count on the fact that he's going to put up a fight. He's going to try to make you as uncomfortable as he can.

That *fat person* is more devious than you can possibly imagine. The more threatened he gets, the more desperate and devious he becomes. He's starting to lose his grip on you.

This is when he starts coming up with the "yeah, buts..." These are his last ditch efforts:

- "Yeah, but no one can change themselves and start thinking that differently from the way they have in the past."
- "Yeah, but this is just somebody trying to kid you into trying again and failing. Just because they did it doesn't mean you can."
- "Yeah, but, it really can't be that easy."
- "Yeah, but, I have more important things to do right now."
- "Yeah, but look at all the trouble you would get into if you lost weight. You couldn't hide, and you would be threatening to other people. Things aren't so bad the way they are now."
- "Yeah, but I don't have what it takes to change."
- "Yeah, but I give so much to other people, and eating is the only thing I give to myself."

A woman named Patty, from San Francisco, shared that she'd found a great way of dealing with those Diet Mentality voices:

I treat them the same way I do my children. Every day my son would come home and tell me the latest thing he'd decided to be when he grew up. One day he would say, "Mommy, I'm going to be an astronaut." The next day he would come home and say, "Mommy, guess what? I'm going to be an engineer!" I would just smile and nod my head. I didn't try to fight with him or reason with him, and I didn't take anything he said too seriously. That's how I started treating the voices. I knew that's just how voices are. You don't have to take what they say to heart.

That *fat person* inside you wants desperately to persuade you that you don't really want to be *naturally thin*. He doesn't want you to give up your invisibility; your excuse to hide and play the game of life for small stakes. He doesn't want you to find out that you have a purpose in life other than constantly trying to lose weight. He certainly doesn't want you to expose yourself to change — to encounter anything new or exciting.

That *fat person* tries to convince you that you won't be able to handle the new challenges of being *naturally thin*. He reminds you that if you lost weight, you wouldn't have anything to complain about. He says, "Who do you think you are?" and tries to make you think it's egotistical to have a *naturally thin* body. He wants to keep things just the way they are.

That *fat person* now commands center court. He has all the attention. That *fat person* knows if you start listening to the *naturally thin* person inside you, his game will be over.

You don't have to let that *fat person* get to you, though. You have a weapon the *fat person* doesn't know about, and it can cut through just about anything: *you know that fat person's game plan*. You know how he operates. You know the tricks he will try to use on you, and you can head him off before he gets started.

You have something even better than that. You have detachment. You can watch him rant and rave and scream as if you were watching a movie. You can wait out the storm, knowing that the

way that *fat person* acts doesn't have to upset you. You can stand firm, knowing that you're not going to beat yourself up for what he's doing. You just wait, watch, and put your attention on taking care of the *naturally thin* person.

Just remember that *the fat person isn't you.* Any time you play his game, any time you interact with that *fat person*, you give him energy and attention. He gains strength. Instead, use that *fat person's* antics to remind you to put even more attention on the *naturally thin* person. Doing this weakens the Diet Mentality. The weaker your Diet Mentality, the stronger the *naturally thin* person inside you becomes.

Exercises (5 minutes)

1. These are the phrases the *fat person* inside of me whispers — or yells — in my ear:

a._____

b._____

c._____

d._____

2. These are the best ways for me to combat those Diet Mentality voices when I hear them:

a._____

b._____

c._____

d._____

e._____

The "Fat Person's" Trump Card

As babies, we have to figure out the best way to get attention. Just about the most effective way to get attention, aside from yelling and screaming, is to do something that pleases other people. If we smile at Mommy and Daddy, for instance, they're ecstatic. They call everyone else over to take a look at us. Please them, earn their approval, and we get all the attention we crave.

Then one day the old trick doesn't work anymore. Say we've been drawing pictures with crayons and the folks have been loving it. We decide to take Mommy's brushes and paints and draw a big picture all over the living room wall. "Won't they be pleased," we think (in "baby," of course).

But when they come home, instead of admiring our masterpiece, they scream at us, give us a whomp on the rump, and send us to bed without supper. "Wait a minute!" we think. "What went wrong?" This was our first major failure to win approval.

After this happens a few times more, we make a decision about ourselves: *"I can't win!"* Then the question becomes *how to avoid losing*. The answer is simple — play small. Don't try to win, don't play 100%. Hold back and maybe they won't notice us. Do as little as possible, don't *ever* put ourselves on the line.

Well, you're not a kid anymore. It's getting down to the wire. You've got to choose between fat and *naturally thin*. This decision will influence the rest of your life.

Choose the Diet Mentality and you wind up playing for matchsticks in a world of abundance. That's the *fat person*'s trump card. Choose to start living a *naturally thin* life and you *might* fail. Being fat and overeating is safe.

This is truly that *fat person*'s last resort. You must play the game, of course, but do so just well enough *not to lose*. Winning is out of the question. This *fat person*'s tactic is so subtle and so pervasive that hardly anyone ever notices.

But you're on to that *fat person*'s tricks and, as any bridge player will tell you, your chance of winning increases dramatically if you know your opponent's cards.

Exercise (6 Minutes)

1. These are the ways I play the game of life for small stakes instead of taking chances and going for what I really want:

a._____

b._____

c._____

d._____

e._____

2. These are some of the ways I might be holding myself back in order to avoid failing:

a._____

b._____

c._____

d._____

e._____

At the Crossroads

So now you have a good idea of why being overweight and holding on to the Diet Mentality can be attractive. It's not so crazy to be fat, or even to choose consciously to overeat.

By now you've also gotten an idea of what it might be like for you to develop your Naturally Thin Mentality. You're well-acquainted with the Diet Mentality. You're at the crossroads. In the next chapter you'll make the big decision.

No one choice is any better, easier or more right than any other. There's only the choice that's appropriate for you. All you have to do now is tell the truth.

Chapter

Making The Choice

The moment of truth has arrived. You have four choices. Select the one that's right for you. It may not be the choice you had in mind when you started *DIETS DON'T WORK*.

Regardless of your choice, make it affirmatively. Choose it, accept it, and begin to purposely live your life from that choice. Ready?

From now on, I choose to be:

1. Fat and Unhappy

Fat and Unhappy is one of the choices from the Diet Mentality. All you have to do is continue what you've been doing.

- Continue on the diet-binge roller coaster.
- Continue to beat yourself up about your weight, your inability to stick to a weight-loss diet.
- Deprive yourself and restrict your activities and relationships because of your weight.
- Worry as much as possible about how much you weigh, and what you're eating or not eating.
- Tell yourself constantly how fat and what a failure you are.
- Above all, keep trying every new weight-loss diet that comes out.

You're already an expert at all of the above, so there's no need to elaborate further. The important part of this option is the truthful acknowledgment that you want to stay the way you have been — unhappy.

Most of us *say* that we want to be happy, but as we've seen, there are a lot of advantages to being Fat and Unhappy. We get attention, we get sympathy, we have excuses, people fuss over us and try to help us.

If Fat and Unhappy is truly what you want, be honest about it. See if you can even have some fun by deliberately being Fat and Unhappy.

People who say they want to be happy and really don't, get stuck in being unhappy until they begin to tell the truth about it. Take a minute to see what you are getting out of being Fat and Unhappy that you wouldn't get if you were, let's say, Fat and Happy.

Jan, who lives in Los Angeles, shared after reading DIETS DON'T WORK, that her frequent periods of depression had disappeared. She realized that she had been using her weight and her overeating to get attention from her husband.

She noticed that whenever she was depressed, he came home early for dinner. During periods of feeling good about herself, he often worked late. She realized that she was getting his attention by being Fat and Unhappy.

Jan decided she wanted to be happy, so she gave up being unhappy. As a result, her depression went away and her husband started coming home early more often.

To get clear in your mind about where you stand with this option, do the following exercise.

Exercise (3 minutes)

These are the benefits I get out of being unhappy:

a._____

b._____

c._____

d._____

e._____

Would you be willing to give these benefits up in order to be happy?

Yes __ No __

2. Thin and Miserable

It's just like Fat and Unhappy except that you spend 98% of your time and energy staying thin by effort, struggle, and one weight-loss diet after another.

3. Fat and Happy

Fat and Happy? You must think I'm kidding. Who could be fat and happy? The two don't go together. It sounds like an oxymoron.

Let's take a look.

Given everything that you've done so far to lose weight and everything you're willing to do (or not willing to do), the truth may be that you are never going to be *naturally thin*. If that's the case, then wouldn't the most practical thing you could do is to accept yourself the way you are and get on with your life?

If deep in your heart you know you aren't willing to do what it takes to be *naturally thin*, then the most sensible, practical, and loving thing you can do is to accept yourself the way you are.

Quit beating yourself up about your weight and your overeating. It's useless. Use that energy to start doing things that are fun and that make *you* happy.

Suppose you had a friend who was thirty-five years old and five feet two. All his life he'd wanted to be six feet tall. He'd gone on all the *tall* diets, done all the tall exercises, bought tall clothes, hoping he would grow into them. He went to doctors, meditated, hoped and prayed, but he never grew. Every day he just became more miserable because he wasn't growing.

As his friend, wouldn't you tell him to give up the idea of being six feet tall, accept himself the way he is, and be happy?

What if it's the same with weight? What if some people are never going to do what it takes to become *naturally thin*? What if staying the way they are and continuing to overeat is really the best choice for them? What would you do? Would you tell your friend to keep torturing himself for the rest of his life?

You may feel that this is a rotten example because you've been indoctrinated with the idea that everybody should want to do whatever it takes to get thin. Anyway, you can't really do anything about getting taller once you are grown.

Oh, yeah? Ever heard of "The Rack"? That piece of torture equipment that was kept in the dungeons of castles. *Everyone* grew that was put on the rack.

Sure, I *know* what you're thinking and you're right! Stretching a person on the rack was, at best, temporary and, besides, it was painful. *So are weight-loss diets!*

Why not just accept being overweight as a neutral fact about yourself, like having brown hair or hazel eyes? What if fat were just fat? Think of all the things you could do if you just gave up and enjoyed overeating and being the way you are.

- You'd never again have to worry about dieting.
- You could buy clothes that were comfortable, rather than buying them one size too small to try to look smaller than you are.
- You could eat as much of whatever you want and enjoy it.
- You could lean back and laugh when people bought weight-loss diet books or wasted time reading about weight-loss diets in magazines.
- You could stop putting your life on hold until after you are thin and start enjoying it fully.

Again and again people have told us that the very act of getting off their own backs about losing weight allowed them to lose it.

Elaine, from Aspen, said:

I couldn't believe what happened when I decided to be fat and happy. It was as if there was nothing to fight against. I lost interest in food. One day, I even forgot to eat dinner. Me, who used to eat at least five meals a day! Since there was no more conflict, eating became rather dull.

It is a great blow to your Diet Mentality when you accept yourself exactly the way you are. Your life naturally starts to turn around. Part of the reason for this "about face" is that you start caring enough about yourself to get off your own back. You eliminate many of your reasons for overeating.

Carol, who lives in Bullhead City, Arizona, is thirty-five and has been *naturally thin* for twenty years. When she was fourteen, she weighed 145, twenty pounds more than she does now.

I was in high school and just miserable. Everything in my life revolved around food — what I was eating, what I wasn't eating, what I was going to eat. It was as if there was a demon inside me that wouldn't let me stop thinking about food or my weight.

Back then, there was not as much information about diets as there is now. I had this instinctive sense that they wouldn't work for me. I knew that even on the off-chance I could stick to one, it would be like living in chains, and I would still hate myself.

I didn't know about the Diet Mentality, but I was a smart kid. I figured out that I had two problems: one was that I was fat, and the other was that I was always worrying about being fat. I figured that I could eliminate 50% of my problems overnight, just by not worrying about it anymore.

At first I thought, "You can't give in like that. It would be like settling for second best. Surely you're a better person than that." It took a lot of humility to accept myself the way I was, but I was so miserable, I would have done anything.

I stopped trying to stuff myself into a size 12 and went out and bought a size 14. I let myself eat what I wanted and just stopped worrying about it.

I don't know how I did it. I just stopped. Every time the voices in my head started screaming, I would remind myself that I was OK.

Then a funny thing started happening. I started losing weight. My mother became worried and took me to the doctor. She thought I had cancer. He said I was in great shape and gave me a clean bill of health.

I continued to lose weight. After six months I was down to 123 pounds, and I've stayed that way ever since, eating exactly what I've wanted.

The results of choosing *Fat and Happy* aren't always as dramatic. If you run away from your weight, deny it, cover it up, then *it's* in control.

We tend to think that happiness comes from outside us — from our circumstances, from other people, from material things, from reaching our goals. The exact opposite is true; happiness comes from within.

We bring the happiness to our circumstances, our relationships, our goals, our lives. Possessions, achievements, other people, can never make us happy. If they could, there would not be so many miserable rich and successful people.

There's an old saying, "Success is getting what you want; happiness is wanting what you get."

You can be happy instantly by wanting what you already have. To be miserable all you have to do is want what you *don't* have. At some point in your life, you did want what you now have. For instance, sometime in the past you decided that you wanted to overeat and you got it.

You can lighten up about the whole situation by acknowledging the truth. Someday you may decide that you want to be *naturally thin.* You'll never get there if you can't accept and have *fun* with your situation as it is right now.

It takes a lot of courage to choose Fat and Happy. It goes against everything written or spoken in our culture on the subject of weight. You can *end* weight as a problem in your life forever in *one instant* just by choosing this option. It's not a problem if it is something you've chosen.

To help you get clear about this choice, please do the following exercises:

Exercises (8 minutes)

1. These are the *advantages* I foresee in giving myself permission to be Fat and Happy:

a._____

b._____

c._____

d._____

2. These are the *disadvantages* I foresee in giving myself permission to be Fat and Happy:

a._____

b._____

c._____

d._____

3. If I accepted myself just the way I am and gave myself permission to get on with my life, I would begin by doing things like:

a._____

b._____

c._____

d._____

4. *Naturally Thin and Happy*

The fourth option you have is to let the *naturally thin* person inside you come forth and take control. Just as some fat people are walking around in diet-induced thin bodies, there are a lot of *potentially naturally thin* people walking around in fat bodies.

If deep in your heart you know that the person inside you is a *naturally thin* person — who is ready to come out — then nothing less than changing your whole mentality is going to work. When your mentality changes, being a *naturally thin* person will be a #1 priority to you in your day-to-day living. It's that simple.

When you are being Naturally Thin and Happy, your commitment will make your daily actions and the results you are producing seem effortless. You will notice yourself demonstrating that you *are* a Naturally Thin and Happy person at every opportunity.

There are no magic pills or other overnight solutions. If there were a weight-loss diet or a magic weight-loss pill, there wouldn't be any fat people left. Everyone would already be thin.

Being Fat and Happy depends on accepting things the way they are. Being Naturally Thin and Happy begins with acknowledging that you used to overeat and consequently gained weight for good reasons.

Given your knowledge and your options at the time, you have *always* made the best choices possible. Now, you have other choices available and it is time to forgive yourself for the past and move on.

Choosing to be Naturally Thin and Happy is a journey into the unknown that's both exciting and scary. It's like changing from a *frog* into a *prince*. In one instant you change.

Naturally Thin and Happy is also a commitment to a new way of life. Understand that the change will bring with it a new set of joys and rewards as well as a new set of problems.

Just as your weight problem is unique, so are your options. You'll need to have the courage to rely on yourself and your *naturally thin* allies. Take your strength from inside yourself rather than from others. *Be willing to make mistakes* as you discover your *own* answers.

Make The Choice

Now that you've seen the four options available to you, the time has come to make the choice. In order to be totally clear about what you want, put a big check mark by *one* of these choices.

____ I choose to be Fat and Unhappy.

____ I choose to be Thin and Unhappy.

____ I choose to be Fat and Happy.

____ I choose to be Naturally Thin and Happy.

Congratulations! You've just made one of the most important choices of your life. Whatever you chose, I applaud you for your willingness to take responsibility for your eating and your weight. You have done what is appropriate for you.

Letting Go

To complete the choosing process, the only thing left now is for you to let go of all the other possibilities and move forward affirmatively in the direction you've chosen.

To illustrate what I mean by letting go, let me tell you a story of Frank "Bring 'em Back Alive" Buck, who trapped wild animals for the circus. Buck had a very interesting way of catching monkeys.

He would take a coconut shell and drill two holes, each on opposite sides. One hole was the size of one finger; the other the size of two fingers. Then he would thread a rope through the coconut with a knot tied at one end.

The knot *was* big enough to pass through the big hole, but would *not* pass through the smaller hole. This made it impossible to pull the coconut away from the rope. Buck would tie the rope to a tree, stuff some wild rice into the coconut, and leave.

When he came back several hours later, he would invariably find a monkey with both hands stuck inside the coconut. The monkey's empty hands were just big enough to fit into the larger hole, but when the monkey's hands were full of rice, the animal couldn't pull his hands back out.

Even when the monkey saw Buck coming, he wouldn't let go of the rice. Buck would throw a burlap bag over the monkey, take him back to the camp, and shake him out into a cage. The monkey would tumble out, holding onto the rice, his hands still stuck inside the coconut.

Buck would reach through the bars and break the coconut open with a hammer to free the monkey. The monkey would immediately stuff the food into his mouth. For a handful of rice, the monkey sacrificed his most precious possession in the world — his freedom. He *made* a choice.

When you make a choice, any choice, you're always giving up something. You can't have all the options at one time. The monkey couldn't have the wild rice and his freedom — he *had* to choose.

Your choice now involves letting go of the past. Regardless of the option you picked, just let go and go forward.

- Right now, as a demonstration of letting go, clench your fists. Hold tight — just as you have to the choices which no longer serve you — until you can't hold on any longer.

- Then, slowly open your hands and imagine feeling those unwanted choices fall away. Just let go.

- What happened? Describe any thoughts, feelings, realizations, memories, or decisions that came to you as you did this letting go process. Use the Notes pages at the back of the book.

Chapter

Where Do You Go From Here?

What happens now? You've worked through all the obstacles. You accept and love yourself. Now it's time to get on with your life.

One of the problems you will face is that a whole world still exists out there that hasn't given up on diets. What if tomorrow the first person you see looks you up and down and says, "You know, my aunt was the same size as you and she went on this great diet." What will you do? Get angry and head for the ice cream parlor? Not any more. Now, you'll take a deep breath, smile, genuinely thank them for their concern and walk on.

Don't argue with or try to convince anyone that you are doing the right thing. People may roll their eyes and laugh when you tell them that you aren't going to diet anymore. It doesn't matter what anyone else thinks about your chosen course.

You will begin to develop an inner-centered reality — when your life is determined by what *you* think, rather than what other people think. You can listen to other people and value their opinions, but in the end the choice is up to you.

If You've Chosen To Be Naturally Thin and Happy

Many people won't understand that you have changed. Now you are eating only when you are hungry and stopping when your hunger disappears. The people in your life are used to relating to you the way they always have. They may worry and shake their heads.

Keep focused on becoming *naturally thin*. Stick to your inner-centered reality. It's only a matter of time before you get a *naturally thin* body to match your *naturally thin* mind. When the pounds start falling away, friends and family will stop worrying.

Exercises (30 minutes)

1. These are the ways I've let other people dictate to me what was important and what I should want and do:

a._____

b._____

c._____

d._____

e._____

2. These are some of the things I *want* to do for myself, rather than what I *should* do for myself:

a._____

b._____

c._____

c._____

d._____

3. If I was *naturally thin*, this is the way I would look:

4. This is how I would feel if I were *naturally thin*:

Breathing Space

It takes about four weeks to break any old habit, another four weeks to establish new ones, and at least another four weeks before the new habits start to become automatic.

It may take *you* one week or one day or nine months. Just remember, this is *your* process and you need to do it *your* way at *your* own speed.

Start On Your Goals

Make a list of everything you can imagine that you might want as a *naturally thin* person — a wish list. Don't worry about how you are going to achieve your objectives. Make sure, however, that you are willing to do what it takes to have these things.

Just look in a mirror and keep asking yourself over and over, "If I could have anything that I wanted, what would it be?" Don't edit what thoughts come to you. Just write them down and keep writing until you run dry.

This is my Wish List:

1. _____
2. _____
3. _____
4. _____
5. _____
6. _____
7. _____
8. _____
9. _____
10. _____
11. _____
12. _____
13. _____
14. _____
15. _____
16. _____
17. _____
18. _____
19. _____
20. _____

(Use more paper if necessary.)

After all your wishes are written down, go back and ask yourself what would be the right date for you to have each wish become a reality.

Some people may keep weight around as a problem because a part of them is afraid that if that problem went away, they would have nothing to do. Their life would become boring. To avoid that trap, begin to work on your goals.

There will be much to do, as you'll see when you start on your list. You may not think you can possibly accomplish some of these goals until you've actually achieved your *naturally thin* body. Putting off accomplishing those goals because you haven't lost all your excess weight is Diet Mentality thinking. Do those first and you will be pushed into thinking of yourself as a *naturally thin* person sooner, rather than later.

You will see that becoming a *naturally thin* person isn't just about losing weight. It's a way to live your life. When you begin to achieve those goals, you'll be amazed at how quickly you'll lose interest in food.

Exercises (10 minutes)

1. What is the first goal you're going to work on?

2. What is the first step you need to take to accomplish that goal?

3. When are you going to take that first step?

4. Make a game plan for thinking like a *naturally thin* person:

When I wake up in the morning, I will...

At 9:00 a.m., I will...

At noon, I will...

At 6:00 p.m., I will...

At 9:00 p.m., I will...

Before I go to bed, I will...

Falling In Love

Only one person in the world will be absolutely guaranteed to be with you for the rest of your life — you. Your relationship with everyone else on earth comes out of your relationship with yourself.

To the extent that you love yourself and recognize your good qualities, you'll love and recognize the best qualities of others. That *fat person* has been a big obstacle in the way of your falling in love with yourself. You saw that *fat person* every time you looked in the mirror. You have judged and criticized yourself harshly and found it hard to love the person you saw.

Now you have the means to replace that negative attention with positive attention. You have the tools to begin a new life and a new relationship with that person in the mirror whenever you choose. It may take some discipline, but it's a positive discipline rather than a negative one.

Remember, at all times and under all circumstances, to think of yourself as the person you want to be, that *naturally thin* person. That person already exists. He or she will be your life-long companion just for the asking. It can be a relationship filled with support, love, and happiness.

You can end weight as a problem in your life forever, today — by replacing the Diet Mentality with a new Naturally Thin Mentality. You can enjoy more joy, peace, and accomplishment in your life than you ever dreamed possible.

It's a simple choice — to think like a *naturally thin* person or to think like that *fat person* with a Diet Mentality. All it takes is permission from yourself to let yourself be whomever you choose.

If You Do Nothing Else...

- At least one day each week, follow the four steps of eating like a *naturally thin* person all day long.
- Work on your incompletions instead of overeating.

If You Are Committed To Staying Naturally Thin

Here are two recommendations:

- Order a copy of the new, expanded, revised edition of *DIETS STILL DON'T WORK — 101 Tips and Strategies for Staying Naturally Thin and Diet-free for the Rest of Your Life.* This book will show you how to avoid the pitfalls of your old Diet Mentality and give you great tips on how to make being *naturally thin* easier and more fun. (See the back of this book for our toll-free, 24-hour ordering number).
- Form your own support group. Share *DIETS DON'T WORK* with others, and reinforce *naturally thin* living for yourself by forming your own *Diets Don't Work Support Group.* The instructions are in *DIETS STILL DON'T WORK* or send me a self-addressed, stamped envelope, and I will send the instructions as a gift to you.

Send your request for instructions to:
Dr. Bob Schwartz
c/o *Diets Don't Work Support Groups*
P. O. Box 2866, Houston, TX 77252-2866.

Please let me hear about your progress on becoming a *naturally thin* person. You can send e-mail to me at my America Online address: DIETSxWORK@aol.com, or write to me at P. O. Box 2866, Houston, Texas 77252-2866.

One Last Acknowledgment

Let's give credit to a man who has been ignored for too long. Before you enroll your friends into your "new" method for losing weight, have them look up the word "Fletcherism" in the dictionary. It's derived from the name of an American nutritionist, Horace Fletcher (1849-1919), and means "The practice of eating in small amounts and only when hungry and of chewing one's food thoroughly."

Remember:
"It Ain't Over 'Til The Naturally Thin Lady Sings"

Breakthru Publishing • 1996 List of Titles

The DIETS DON'T WORK Collection

DIETS DON'T WORK (New, Entirely Revised 3rd Edition)
Stop Dieting! Become "Naturally Thin" Live A Diet-free Life
by Dr. Bob Schwartz , Ph.D.

The *New York Times* Best Seller recommended by universities and physicians all over the United States, Canada, and England. For anyone struggling with weight or food and who has failed in the past to either lose all their weight or keep it off.

Only $15.95 (Hardcover), $12.95 (Softcover)

DIETS STILL DON'T WORK
101 Tips and Strategies For Staying Naturally Thin and Diet-free For The rest Of Your Life
by Dr. Bob Schwartz, Ph.D.

This book will show you how to avoid the pitfalls of your old "Diet Mentality" and give you great tips on how to make being *naturally thin* more fun and easier..

Only $15.95 (Hardcover), $12.95 (Softcover)

DIETS DON'T WORK! (First Edition)
by Dr. Bob Schwartz, Ph.D.

The one that started it all! The *New York Times* Best Selling 1982–1992 *First Edition*. Limited number of copies are still available at a reduced price.

Only $9.95 (Softcover)

The DIETS DON'T WORK! Audio Cassette Tapes
Spoken by Dr. Bob Schwartz, Ph.D.

This double-cassette album incorporates over two hours of inspiring ideas from *DIETS DON'T WORK!* live seminars, private consultations, and the *DIETS DON'T WORK!* and *DIETS STILL DON'T WORK!* books.

Only $29.95 (Cassette Album)

The DIETS DON'T WORK! Video
Eighty minutes of video footage from a "live" *Diets Don't Work* seminar conducted by Dr. Bob Schwartz. This video program will help you, as it helped thousands of others, to lose weight, and keep it off forever.

Only $39.95 (VHS)

SELF-TALK FOR WEIGHT LOSS
by Dr. Shad Helmstetter, Ph.D., and Dr. Bob Schwartz, Ph.D.
This book contains the latest breakthrough discoveries on how early "programming" can control your habits, thoughts, and actions around food and weight. Learn why permanent weight loss is impossible for most people until they learn how to change the invisible mental programs that hold them back.
Only $22.95 (Hardcover)

The Basic DIETS DON'T WORK! Package Plan
This money-saving weight-loss program gives you all the basic information you need for you to learn how *naturally thin* people stay thin. Stops you from making the same mistakes that almost all overweight people make when they try to lose weight. You can start losing weight within a few hours of receiving your basic weight loss kit. Just plug in either your audio tapes or your video tape and you will feel yourself becoming *naturally thin*. This program is the next best thing to being in one of Dr. Schwartz's *Diets Don't Work* live seminars. This basic package contains (1) a copy of *DIETS STILL DON'T WORK*, (2) the instructional *DIETS DON'T WORK* Audio Cassette Tapes, (3) the *DIETS DON'T WORK* Personal Seminar Video, and (4) a copy of *SELF-TALK FOR WEIGHT LOSS*.
Only $69.95 (Set)

DIETS DON'T WORK Consultations & Workshops
with Dr. Bob Schwartz, Ph.D.
Call for details

The Breakthru Collection
Money and Management Success

The 33 Ruthless Rules of Local Advertising
by Michael Corbett
A fact-based, no-nonsense mathematically-grounded system of advertising that has produced remarkable growth for countless local businesses, in *any* economy, no matter how strong the national or local competition! Contains a special bonus section: *Common Sense Marketing*.
Only $25.00 (Hardcover)

The 33 Ruthless Rules of Local Advertising
Audio Cassette Tapes
Read by Michael Corbett and David Stilli
This three 90-minute cassette album is the complete and unabridged audio version of the book.
Only $39.95 (Cassette Album)

The Ultimate Guide to Relationships and Romance Collection for "Naturally Thin" People

THE ONE HOUR ORGASM
The Ultimate Guide to Totally Satisfying Any Man or Any Woman...Every Time! (New, Revised 2nd Edition)
by Dr. Bob Schwartz, Ph.D.

Many people think that making love and satisfying one's partner should be instinctive, but for most people relationship skills and fulfilling sex is something that needs to be learned. Re-creating the course on Basic Sensuality that has been taught at More University in California for the last 25 years, Dr. Schwartz offers a proven method of achieving both a truly satisfying sex life and an enriched relationship with one's partner. Recommended by the American Institute of Sexual Studies.

Only $12.95

THE ULTIMATE GUIDE TO TOTALLY SATISFYING ANY WOMAN EVERY TIME! Video

A very explicit and educational demonstration of *The One Hour Orgasm* technique. Caution! Adults-Only education. Contains nudity. Teaches a man now to increase his sexual, sensual, communication, and intimacy skills. Demonstrates the love making technique taught at More University in California for over the last 25 years. Designed to help men give their women the most intense and longest lasting pleasurable feelings possible. Featured on HBO's *Real Sex* series! Available in English or Spanish.

Only $39.95 (VHS)

THE ULTIMATE GUIDE TO TOTALLY SATISFYING ANY MAN...EVERY TIME! Video

This is the companion to the TOTALLY SATISFYING ANY WOMAN video. Teaches women how to initiate lovemaking in a fun and effective way without any help on the man's part. At any age, an important technique to reducing a man's fear of impotency and premature ejaculation. Available in English or Spanish.

Only $39.95 (VHS)

THE ULTIMATE GUIDE TO MAKING A RELATIONSHIP WORK Video

This video is a must for everybody whether contemplating a relationship or already in one. MAKING A RELATIONSHIP WORK deals with the invisible rules which cause most arguments and divorces. Discover how to put the fun back into an old relationship, the quickest way to repair an unhappy relationship, and how to build a relationship which keeps getting better and better!

Only $39.95 (VHS)

THE ULTIMATE VALENTINE Video

This video is a must for Valentine's Day or any other day. Educational, inspirational, and fun. Six seductive scenes will give you some great ideas on how to sweep your Valentine off their feet any day of the year. Must be over 21 to order.

Only $39.95 (VHS)

The ULTIMATE GUIDE Money-saving Package

A great deal! Buy two videos and save $20.00. Buy three videos and save $30. Buy the complete set of four and get $40.00 OFF, plus a FREE copy of *The One Hour Orgasm* (a $12.95 value).

Any 2 Videos – Only $59.90

Any 3 Videos – Only $89.85

All 4 Videos (plus a copy of The One Hour Orgasm) Only $119.80

New To The Relationships and Romance Collection

CRACKING THE LOVE CODE

by Janet O'Neal

This nationally-renowned "Love Coach" reveals, after ten years of research with thousands of people, six major principles which are guaranteed to work in attracting, dating, marrying, and keeping the right person. We recommend this book because it could keep you from wasting years dating or, even worse, marrying someone who's wrong for you.

Only $15.95

HOW TO FIND REAL LOVE WITH THE RIGHT PERSON
Audio Cassette Series

by Janet O'Neal

A series of 6 audio tapes guaranteed to help you immediately start winning at dating, romance, sex, and even marriage. Included is Janet O'Neal best-selling book, *CRACKING THE LOVE CODE*.

Only $59.95

See next page for ordering information

Ordering Information

For fastest service call our toll-free, 24-hour order line:
(800) 227-1152 or (713) 522-7660

To order by mail, please write to:
Breakthru Publishing
P.O. Box 2866
Houston, Texas 77252-2866

Please add a shipping charge of only $5.00 for as many items as you order (shipped to the same address).

Texas residents add 8.25% for sales tax.

If you wish to receive your order by priority service, or you wish to discuss discount pricing on quantity orders of our products for gifts or for resale, please call (800) 227-1152.

Sorry, no CODs.

Notes

Notes

Notes

Notes